i lemuri 13

Cover
Agnolo Bronzino, *Portrait of Maria di Cosimo de' Medici*, 1551. Florence, Gallerie degli Uffizi

Art director
Paola Gallerani

Layout
Irene Paoloni

Editing
Michèle Fantoli

Color separation
Giorgio Canesin

Printed by
Intergrafica, Verona

Press office
Luana Solla

ISBN: 978-88-3367-178-9

© Officina Libraria, Roma, 2023

Officina Libraria
Via dei Villini 10
00161 Roma

Printed in Italy

Information on our new titles, backlist, events, extra-contents on
◯ officinalibraria.net
⬤ Officina.Libraria
◉ officinalibraria

Special thanks to Alessandro Salvatici.

Photographic references
Bayonne, Musée Bonnat-Helleu, A. Vaquero: p. 19
Florence, Gallerie degli Uffizi: p.10, p. 13, p. 15, p. 17, p. 22, p. 26, p. 31, p. 32, p. 37, p. 39, pp. 44-46, p. 48, p. 51, p. 55, p. 57, p. 59, pp. 62-63, pp. 65-66, p. 69, pp. 71-73, p. 76, p. 78 pp. 81-82, p. 84, p. 86, p. 88, pp. 90-91; Gabinetto Disegni e Stampe: p. 49; Palazzo Pitti, Galleria Palatina: p. 25, p. 33, p. 35, p. 52, p. 75, p. 80, p. 85, pp. 94-95; Palazzo Pitti, Tesoro dei Granduchi: p. 42, p. 56
Florence, Archivio di Stato: p. 70
Florence, Biblioteca Marucelliana: p. 74
Prague, Národní Galerie: p. 41

Printed in the month of May 2023
Intergrafica, Verona

Ex Officina Libraria Jellinek et Gallerani

Adele Milozzi

MEDICI PORTRAITS

AT THE GALLERIE DEGLI UFFIZI

GUIDE

OFFICINA
LIBRARIA

TABLE OF CONTENTS

INTRODUCTION

Walking into the Gallerie degli Uffizi or Palazzo Pitti's Galleria Palatina and standing before the Medici portraits, visitors have the special opportunity to discover the features and spirit of some of the most important figures of the Italian Renaissance and its subsequent celebration.

Portraiture is by nature a genre that can cross over centuries, revealing a person's features and even psychology, while at the same time preserving the trace of the historical period during which the work was made. The essential component of the portrait is not so much the dynastic aspect as the desire for self-representation and the political message the sitter wished to communicate through the work. These are unique aspects of an artistic genre of which patrons were fully aware, and so, although cognizant of the fact that we are standing before inanimate objects, we need to always keep in mind that the men and women that we meet in these paintings had themselves portrayed in this way for precise reasons. To satisfy this desire for self-representation, the artists came up with sophisticated new solutions, often in fruitful collaboration with the humanists, scholars and court advisers of the time.

As in the models from antiquity, which were drawn upon for the representation of the first generations of the Medici dynasty for their overt political implications, Medici portraiture attests to the power of the family, the expansion of Florence and Tuscany and the relation between family dynamics and public claims. Looking at these paintings takes us through four centuries of history, from Humanism to the Enlightenment: a parade of works that reveals how artists, and not just Tuscan, expressed their personal style while respecting the needs and iconographic and compositional limitations of the portrait genre, at the same time varying it with innovations.

The links between representational models and the individual character of the sitters, and more generally the cultural complexity to which these works attest, can be better understood with the aid of documents, correspondence and literary

works composed by contemporaries, including the immensely valuable 1550 and 1568 editions of Giorgio Vasari's *Lives of the Most Excellent Painters, Sculptors and Architects*. From these sources, we come to understand the decision to reinstate the celebratory and commemorative value of the profile pose, drawn from classical glyptics and numismatics, already dominant in fifteenth-century Florentine portraiture, for Pontormo's portrait of Cosimo the Elder (p. 13) and Vasari's portrait of Lorenzo the Magnificent (p. 17). Given the need to refer to existing models in order to accurately reconstruct the features of the deceased, typically medals or death masks, this compositional solution is traceable to the representational canons of the period during which the subjects lived and the interest in the antique that flowed through scholarly milieus in the early sixteenth century, in the context of the political function of the nascent court portrait, to which Vasari returned on multiple occasions. The patron for Vasari's portrait of Lorenzo the Magnificent was the first duke of Florence, Alessandro de' Medici, who was also portrayed by Vasari in a classicising work in the Uffizi (p. 32), the celebratory aim of which is expressed through innovations so original that the artist felt compelled to expound upon them in an inscription incised on the original frame.

With the rise of Cosimo I in 1537 and the formalisation of the family's power, the aim of Medici portraiture became to consolidate its authority and legitimise the dynasty: the still-young future first grand duke found in Bronzino the perfect artist for lending the public family image a rarefied aura and a dynastic dignity that was then continued by his student Alessandro Allori. Under Cosimo I, the circulation of the public image of other family members began to be controlled as well, as evidenced by numerous copies in the collections of the world's most important museums, often sent by Florence to the other courts as diplomatic gifts, the prototypes for which were typically works in the Medici collection. The aim of legitimisation and self-celebration was behind the project launched by Cosimo's successor, Francesco, and carried out between 1584 and 1586, for a series of twenty-two portraits of family members for the decoration of the Galleria degli Uffizi, all the same size and the same knee-length format. These were the first paintings in the 'Serene Princes series' that took the name 'Serie Aulica' in the Medici exhibition of 1939 in which some of the works were displayed. The collection, which continued to be expanded up to the very last grand dukes of the family, ended up

totalling forty paintings, first on wood and then canvas. Between 1587 and 1591, Ferdinand I decided to combine this group of illustrious ancestors with another series of portraits hitherto kept in Palazzo Vecchio: the renowned 'Giovio Series' commissioned by Cosimo I and comprising copies made by Cristofano dell'Altissimo of the vast group of portraits of famous people from across history collected by Paolo Giovio and displayed in his Musaeum on the shores of Lake Como, figures with whom the lords of Tuscany considered themselves to be in the same league.

Looking at the Medici portraits from one generation to the next, you find the astonishing psychological rendering of the sitters portrayed by Titian and Scipione Pulzone's talent for combining extreme naturalism with the solemn tone required for an official portrait, as well as the patrons' admiration of the work of Baroque painter Justus Sustermans, who was the Medici court portraitist for decades and many of the paintings by whom were gathered into a special room in Palazzo Pitti in 1678 by Cosimo III, in a kind of solo exhibition ahead of its time.

For the Medici, the function of portraiture was purely public, as revealed by the episode in which Raphael's splendid portrait of *Leo X with Cardinals Giulio de' Medici and Luigi de' Rossi* (p. 22) was displayed in lieu of the pope during the wedding banquet for Lorenzo de' Medici, duke of Urbino and Madeleine de La Tour d'Auvergne in 1518. This artistic genre was also central to marriage politics, a fundamental tool for the social elevation of the family and the art of government. Proof is found in the missive with which the first secretary Belisario Vinta, sent by Francesco I to Innsbruck in 1578 to open marriage negotiations with the transalpine court, asked the grand duke to send him a portrait of his daughter Anna, to ease negotiations by putting to rest the rumours that she was melancholic and disfigured: 'the Archduke has been told that Anna ruined her face in a fall, one of her eyes is always wet with tears and her face is pallid, which Your Highness will be able to put right by sending a portrait'.

In the short space of a guide and concentrating on the cream of the crop from the rich collections of the Gallerie degli Uffizi and the Galleria Palatina, this volume outlines a few aspects of the lives and portraits of the most important members of the best-known family of the Italian Renaissance, at the same time suggesting a few points for reflection that visitors might like to consider during their first-hand encounter with the Medici 'from life'.

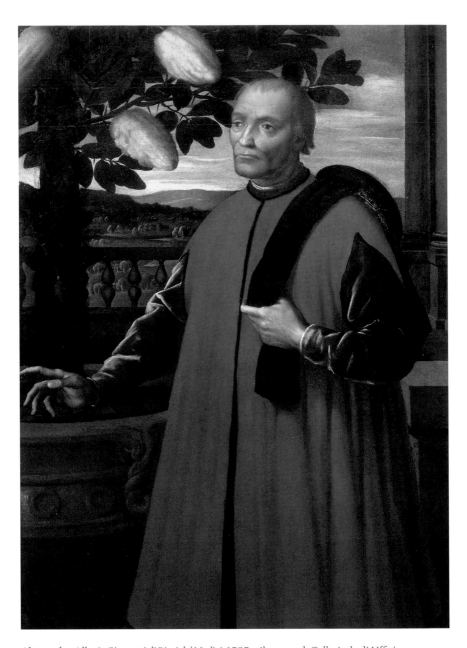

Alessandro Allori, *Giovanni di Bicci de' Medici*, 1585, oil on panel. Gallerie degli Uffizi.

THE CAFAGGIOLO MEDICI AND THE POPOLANI BRANCH
GIOVANNI DI BICCI (1360–1429)

In his portrait of Giovanni di Bicci de' Medici, Alessandro Allori included an apparently decorative element that is revealed to be the cornerstone of the representation as soon as its meaning is understood. The figure stands in a terrace transformed into a hanging garden, a setting popular in Florence during the time of Francesco I (the patron of this painting belonging to the Serie Aulica), and often used by women, who could thereby enjoy the health benefits of being outdoors without leaving their homes. A large citron tree stands out on the left, planted in a terracotta pot that was produced in Impruneta, home to specialised kilns dating back to the Middle Ages and that enjoyed intense development under the government of Grand Duke Francesco and his father Cosimo. The fruit of this tree, depicted near Giovanni's face, is the key to interpreting the work: the Latin name for this citrus fruit is *citrus medica*, and hence a clear reference to the name of the family, which, like the flourishing fruit, prospered and bore fruit thanks to the labour of Giovanni di Bicci.

Like his brothers, Giovanni, founder of the Medici economic empire, received a modest inheritance from their father, Averardo, known as Bicci. Enterprisingly, he sought employment from Vieri di Cambio, a relative, who first gave him the job of administering some farmland and then his bank in Rome, of which Giovanni later became a partner, investing the dowry of his wife, Piccarda Bueri. When Vieri retired, Giovanni took over the business and financed the projects of Baldassarre Cossa, who, elected pope (later declared 'antipope', until the Western Schism ended with the election of Martin V) under the name John XXIII, put him in charge of collecting tithes, the activity at the base of the economic success of the Medici bank. In Florence, in 1421, he held the post of Gonfalonier of Justice; he carried out ambassadorial duties and was a member of the Dieci di Balia, but he never had political aims, preferring instead to build a client network across every layer of society, nurturing good relations as much with the city oligarchy as with the common people, a strategy that positioned him to influence the choices of the Florentine government. Giovanni di Bicci's shrewd and refined political intelligence was just as valuable an inheritance for his descendants as the astonishing economic wealth he accumulated.

Giovanni di Bicci's eldest son, Cosimo the Elder, was head of the main branch of the Medici family, the 'Cafaggiolo' line, while Lorenzo the Elder (1395–1440) was that of the cadet branch, the Popolani or 'Trebbio' line. The two branches were linked by complex relationships: Pierfrancesco di Lorenzo il Vecchio (1430–1476) had been close to Luca Pitti when the latter conspired to murder Piero the Gouty, son of Cosimo; and yet, when he died, his children with Laudomia Acciaiuoli, Lorenzo (1463–1503) and Giovanni (1467–1498), were taken under the tutelage of Piero's son, Lorenzo. However, the latter, who would later become known as 'the Magnificent', refused to give them back the 53,000 florins they had inherited from

their father, which had been used to resolve a liquidity crisis at the Medici bank. Lorenzo and Giovanni – who then took the name 'Popolano' to distinguish themselves from their cousin Piero the Fatuous, who had been banished from Florence – sued, and opened their own bank, the Seville branch of which was where Amerigo Vespucci, who they had sent to work there in 1491, made connections that helped him make his voyages to America.

PATER PATRIAE
COSIMO THE ELDER (1389–1464)

When the Piccolomini pope Pius II asked him to support one of his military endeavours, Cosimo de' Medici, later called 'the Elder' to distinguish him from his namesake successors, replied that he was merely a private citizen happy with his life, no matter how commonplace. The highly cultured pope doubtless understood that this artful reply was in keeping with Cosimo's shrewd management of power, which he handled in a way that was formally respectful of Florence's republican institutions, in which he rarely held an official role (he was Gonfalonier of Justice and prior of the Guild of Bankers and Money Changers), but made him de facto lord of Florence.

The son of Giovanni di Bicci, Cosimo had inherited considerable wealth from his father, which he increased and used wisely to benefit the populace, for public and private patronage and in support of conditions favourable to trade. Intelligent, rich and determined, Cosimo was not just the *homo novus* of the family, he reorganised the socio-economic structure of Florentine political life, which saw the formation of the Medici 'party', a growing group of talented, extremely loyal men who, sometimes overcoming the limitations of the social class they were born into, contributed as much to increasing Medici power as to the civil and cultural progress of Florence.

Pontormo made this posthumous portrait of Cosimo the Elder drawing information for his portrayal from portrait medals, hence the profile pose. Cosimo is seated on a high-backed chair with his hands clasped, wrapped in a rich winter garment of heavy dark red cloth lined with fur, which can be glimpsed inside the collar and the wide sleeves. Demonstrating his perfect mastery of the technique, after applying the final layer of paint, Pontormo used the tip of the brush to scratch the areas of light on the clothing, revealing the paint beneath and enlivening the rendering of the fabric. The face hollowed by age, creating deep shadows, the rich but not flashy clothing and the composed pose lend the sitter an air of quiet dignity appropriate for the title inscribed in abbreviated form on the back of the chair: the letter 'P' repeated three times next to Cosimo's Latin name, standing for *Pater Patriae Publice* (father of his country by will of the state), an honorific granted to him 'by public decree', as we read on his tombstone. Cosimo sits facing a laurel branch, evoking the Medici device of a cut trunk from which a new branch emerges, symbolising the family's capacity for self-renewal. A cartouche loosely wound around the branches is inscribed with a passage from Book

VI of the *Aeneid*: uno avulso non deficit alter (as one is torn away another appears), expressing the guarantee of generational continuity and the programmatic will of the new Medici to equal their illustrious ancestor.

When Cosimo died, his son with Contessina de' Bardi, Piero (1416–1469), known as 'Piero the Gouty' for the disease he, and almost all the Medici, suffered, took over

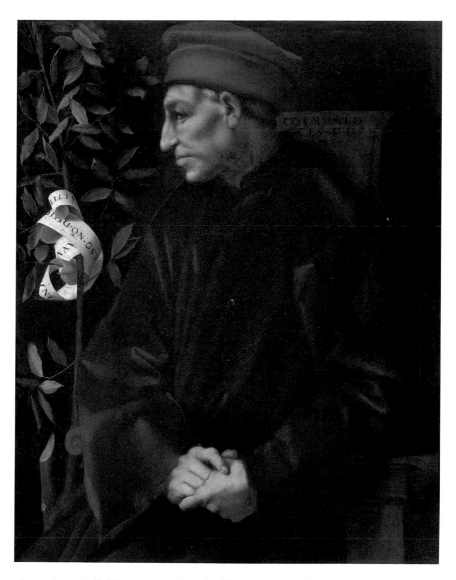

Jacopo Carucci called Pontormo, *Cosimo The Elder*, 1519-1520, oil on panel. Gallerie degli Uffizi.

management of the family bank and the political influence his father had wielded in the city. He died when he was fifty-three, leaving the burden of public life and the family business to his children with Lucrezia Tornabuoni: the twenty-year-old Lorenzo and, to a lesser degree, Giuliano, who was just sixteen. According to a popular saying, the fortune created by the grandfather is increased by the father and destroyed by the grandson, but Lorenzo confounded this proverb, and is indeed universally known as 'Lorenzo the Magnificent'.

A PRESTIGIOUS ECCLESIASTICAL CAREER
CARLO (1428/30–1492)

This painting, one of the most beautiful surviving portraits by Andrea Mantegna, was long believed to depict a member of the Gonzaga family, for whom Mantegna was court painter. Now, however, the sitter is generally identified as Carlo de' Medici, the illegitimate son of Cosimo the Elder and, presumably, a Circassian slave purchased by the latter in Venice in 1427, as we learn from the contract of purchase drawn up in the lagoon city. The dark complexion would have come from his mother's side, colouring that brings out the intense blue of his eyes, a feature that does not, however, help towards identifying the sitter, since the colour of Carlo's eyes is not mentioned in the archival documents. As a young man, he was started off on an ecclesiastical career and resided in Rome for many years, where he acquired objects for the Medici collections, in particular on request from his half-brother Giovanni, to whom he wrote in a letter dated 31 October 1455 that he had purchased about thirty silver medals from a student of Pisanello, but that when Cardinal Pietro Barbo, the future Pope Paul II, found out about the deal, he stopped him and stripped him of all of the valuables he had on him: 'he took rings and seals and money that I had in my purse from me, to the value of twenty florins, and would not return them until I handed over the above-mentioned coins'.

While we cannot be certain of the identity of the sitter in Mantegna's painting, there are many arguments in favour of it being a portrait of Carlo de' Medici. If it were, it might have been painted in connection with the Council of Mantua in 1459 or during the painter's stay in Florence in 1466. In favour of this identification, this painting was used as a model for the portrait of Carlo in the Medici family tree made in about 1589 by the engraver Martino Rota. Some scholars also argue that Mantegna's painting draws on a commemorative medal sculpted in relief by Vincenzo Danti between 1561 and 1564 for Carlo's funerary monument, commissioned by Cosimo I for the Prato Cathedral where Carlo was parish priest. Based on Vasari's report that Carlo is among those portrayed in the fresco cycle painted by Filippo Lippi in the choir of the same cathedral, dedicated to St Stephen, some have proposed that

Andrea Mantegna, *Carlo de' Medici*, 1459 or 1466?, tempera on panel. Gallerie degli Uffizi. ▶

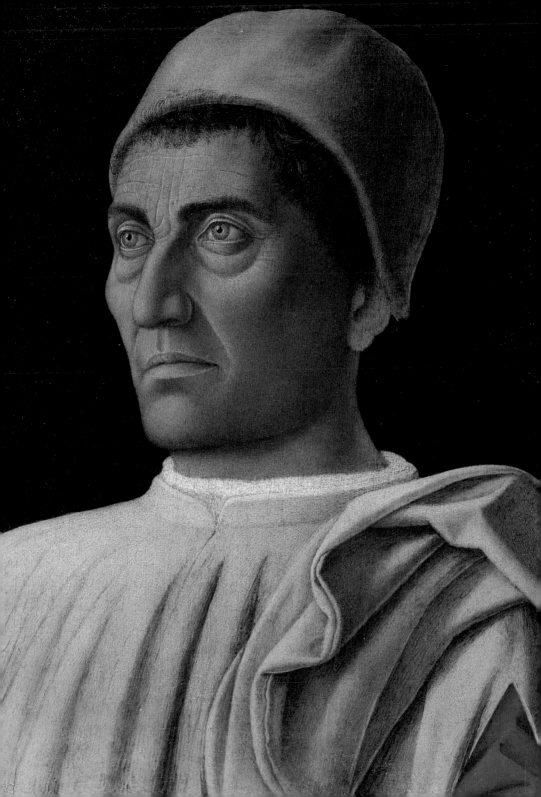

he is one of the prelates standing on the right in the scene of the *Funeral of the Saint*, and are further convinced that Danti found his model for the medal there as well.

Despite its poor state of preservation and the changes made to the work, this potent painting continues to stand out for the descriptive rigour of the man's physiognomy and the minute, even ruthless, definition of his harsh, deeply lined face, lit by an oblique light source on the left, that expresses the grave seriousness of the sitter. One also appreciates the painter's skill in describing the material aspect of the fabrics, harmoniously represented in masses of colour from vermilion to pink in an evocative, vigorous whole.

THE RENAISSANCE MAN
LORENZO THE MAGNIFICENT (1449–1492)

This portrait of Lorenzo the Magnificent was commissioned from Giorgio Vasari and conceived as a pendant for the one of Cosimo the Elder by Pontormo, almost mirroring the pose. Lorenzo is wearing a sober garment, albeit sumptuously trimmed in fur, and surrounded by eccentric, all'antica objects, including a strange terracotta oil lamp in the shape of a mask with a stopper stuck into the open mouth, an allusion to his illuminating eloquence, as made clear by the Latin inscription on the pillar upon which he is resting his arm: SICUT MAIORES MIHI ITA ET EGO POSTERIS MEA VIRTUTE PRAELUXI (Just as my ancestors shone forth in their virtue so I shine forth for my descendants). On the right, there is a chased pitcher bearing the inscription VIRTUTUM OMNIUM VAS (vessel of all virtues), above which we find another mask, this one monstrous, on a baluster with the inscription VITIA VIRTUTI SUBIACENT (virtue triumphs over vices). This enigmatic iconography, supported by the inscriptions scattered throughout the painting, was illustrated in a letter from the painter to his patron, in which Vasari explained that the mask with the monstrous features stood for driven back vices, while the other, jokingly hung on the spout of the pitcher, almost overlapping with the sitter's face, has beautiful, clean forms that reference the best moral values. The political message of the painting commissioned by the duke Alessandro, Lorenzo's nephew, is clear: Lorenzo had been virtuous and his descendants, whose steps are illuminated by the light of his lofty example, will be able to do just as much for the good of Florence.

In an Italy broken up into enemy signories, an alliance with Florence became politically decisive, to the point that, when Lorenzo the Magnificent died, Guicciardini described the city as 'almost like a balance for all Italy'. Intensely committed to patronage of the arts, Lorenzo opened the doors of the garden of San Marco for the training of young artists, a place where even Michelangelo, living as a guest in Lorenzo's home, had the opportunity to study the ancient statues in the Medici collection from life. Although his wielding of power was not without dark patches, Lorenzo was industrious, one of the few to remain in Florence during the plague

Giorgio Vasari, *Lorenzo The Magnificent*, 1533–1534, oil on panel. Gallerie degli Uffizi.

of 1478/79, and prodigious, viewing his wealth as a tool for achieving high aims and not as an end in itself. In his *Ricordi*, he wrote: 'I find that from 1434 till now we have spent large sums of money ... for alms, buildings, and taxes ... But I do not regret this, for though many would consider it better to have a part of that sum in their purse, I consider that it gave great honour to our State, and I think the money was well expended, and am well pleased.' Even though his wealth could rival that of the most powerful of his time, Lorenzo excelled above all in the cultural milieu, whether supporting artists and circulating Tuscan art across Europe, or promoting the *Raccolta aragonese* (1476), an anthology of poems by the most important Tuscan poets, from Dante to Guido Cavalcanti and up to the fifteenth-century writers and Lorenzo himself, which he gave to the king of Naples Frederick of Aragon in order to show up the literary dignity of the vernacular. Immersed in humanism's recovery of ancient culture, Lorenzo proposed a renowned interpretation of Horace's *Carpe Diem* in his famous *Canzona di Bacco e Arianna* (*Triumph of Bacchus and Ariadne*), composed for Carnival in 1490 and meant to accompany the allegorical/mythological chariots as they paraded through the streets of Florence: 'How beautiful youth, which is ever in flight! He who so wishes, let him be merry: There is no certainty of tomorrow.'

THE PAZZI CONSPIRACY
THE ASSASSINATION OF GIULIANO DE' MEDICI (26 APRIL 1478)

'I am resolved to describe briefly the Pazzi conspiracy, a crime most worthy of record that occurred in my own times, for indeed it almost overthrew the whole Florentine Republic from within': thus began Angelo Poliziano's *Coniurationis commentarium*, a dramatic account of the attack that culminated with the injury of Lorenzo the Magnificent and murder of his brother Giuliano (1453–1478) in the Florence Cathedral, an event for which the poet and philologist was an eye witness.

In 1471, the newly elected Della Rovere pope, Sixtus IV, gave the Medici bank management of the Depositeria, the treasury of the Papal State. The Medici therefore had the honour of being the official bankers of the pope, with low probability of recouping the capital lent but alluring prospects of profits from the contract for collecting taxes owed the pope. When Sixtus IV expressed interest in acquiring the signoria of Imola for his nephew Girolamo Riario with the aid of a substantial loan from the Medici bank, Lorenzo rejected the deal and tried to force other Florentine bankers to do the same, since Imola was also a strategic city for Florence. The loan was provided all the same by the Pazzi bank, which thereby secured management of the Depositeria for itself. In 1473, Girolamo Riario became lord of Imola and the following year, Francesco Salviati, cousin of the Pazzi and hated by the Medici, was appointed archbishop of

Pisa. But then, in 1477, Lorenzo used his influence to have a law passed that forbade daughters from inheriting paternal assets in favour of close male relatives: this provision was a direct hit on the inheritance of Beatrice Borromeo, wife of Giovanni de' Pazzi and the only daughter of the wealthy merchant Giovanni Borromeo, who, despite being named by her father as his sole heir, was forced to cede the vast fortune to her cousin Carlo.

It was within this tense climate that Jacopo and Francesco de' Pazzi developed their plan to remove the Medici from the government of the Florentine republic, killing the head of the family, Lorenzo, and his brother Giuliano, perhaps following the example of the murder of the duke Galeazzo Maria Sforza organised in 1476 by the Milan aristocracy. Although the two Florentine families were on familiar terms and there was even a marriage between Lorenzo's sister Bianca and Guglielmo de' Pazzi, it would have still been difficult for Francesco to catch the Medici brothers undefended. A perfect occasion seemed to be provided by Cardinal Raffaele Riario Sansoni's passage through Florence, on his way to Umbria as papal legate, where he had been sent by the Della Rovere pope, his relative. The assassination attempt, at first planned to take place during a banquet in honour of the cardinal at the Medici villa in Fiesole, was postponed because Giuliano had taken ill and did not attend. To ensure that he would not be absent again in Florence, on the morning of 26 April 1478, Francesco de' Pazzi

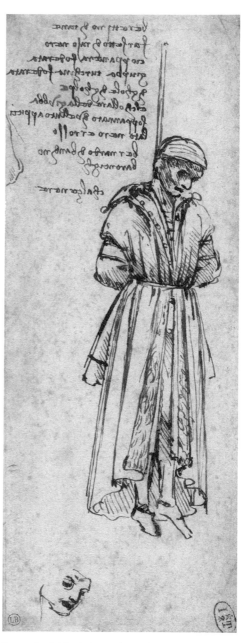

Leonardo da Vinci, *Bernardo Bandini Baroncelli hanged*, 29 December 1479, brown ink on paper (recto). Bayonne, Musée Bonnat-Helleu.

and Bernardo Bandini – or Baroncelli – went to the Medici palace to personally accompany Giuliano to the Mass that Riario Sansoni was celebrating in the cathedral. In the *Istorie fiorentine*, Niccolò Machiavelli reports that, along the way, Pazzi playfully embraced his designated victim as young people do, but 'so as to see if he were provided with either a cuirass or other similar protection'. During the most solemn moment of the Mass, the Eucharist, Bandini struck Giuliano in the heart with a dagger. Taking a few steps, he fell to the floor lifeless. Francesco de' Pazzi swept down upon him all the same, delivering blow after blow in blind rage, going so far as to injure his own leg. At the same time, the papal vicar Antonio Maffei da Volterra and the presbyter Stefano da Bagnone attacked Lorenzo, who, however, managed to react and was pulled by friends to safety in the sacristy, from which he could hear the conspirators stir up the populace with the cry 'Liberty! Liberty!' The Pazzi did not, however, win the support of the state officials gathered in the Palazzo dei Priori (now Palazzo Vecchio) nor that of the populace, which responded with the cry 'Palle! Palle!', alluding to balls of the Medici crest. Lorenzo's reaction of immediate outrage, sharpened by the pain of his brother's murder, was merciless: in just a few hours, Francesco de' Pazzi and the archbishop of Pisa Francesco Salviati had been captured and hung from the windows of the Palazzo dei Priori. In the days that followed, Jacopo de' Pazzi and his men were next. The only one to escape was Bernardo Bandini, who managed to flee to Constantinople. Their bodies were thrown into the Arno or buried outside consecrated ground. And a group of boys who had gotten hold of Jacopo's body were allowed to drag it naked through the streets of Florence and beat its head on the doors. The condottiere Giovan Battista da Montesecco, who had refused to murder Lorenzo, and especially in church, but had not divulged the plot, was judged guilty all the same: tortured to reveal the details of the conspiracy and the names of those who supported it (including the pope and the king of Naples), he was then beheaded in the Piazza della Signoria. In time, the savagery quieted down, Florence resumed its path towards civil progress and the political role of Lorenzo de' Medici was never again formally questioned.

The finale to this dark chapter in Florentine history took place when sultan Mehmed II, who had excellent trade relations with the signoria of Florence, was happy to hunt down Bernardo Bandini and deliver him to Florence in chains. The fugitive was hung from the windows of the Palazzo del Capitano del Popolo (better known as the Palazzo del Bargello) on 29 December 1479, wearing the eastern clothing he had on when he was captured. And that is how he was portrayed by an exceptional eyewitness, Leonardo da Vinci, in a pen and ink drawing upon which he noted, in his distinctive 'mirror' writing, the materials and hues of the unusual garments.

THE SON OF LORENZO THE MAGNIFICENT BECOMES POPE
LEO X (1475–1521)

'You are not only the youngest cardinal in the college, but the youngest person that ever was raised to that rank', Lorenzo the Magnificent wrote to his son Giovanni in 1492, in a letter packed with advice for the future. The young Medici was created cardinal by Innocent VIII when he was just thirteen, under pledge to keep the news secret and banned from wearing the insignia of his new rank for three years. Lorenzo had devoted much time and effort to obtain a cardinalship for his son, nurturing shrewdly chosen relationships so that his child, still a boy but very gifted, would be able to 'favour [his family] and [his] native place'. In his letter, Lorenzo explained the delicate nature of his role in Rome, that 'that sink of all iniquity', but increasingly key to Italian politics, as well as the need to always remain above reproach and wary at the papal court, which was teeming with people who would 'endeavour to corrupt and incite [him] to vice', towards promoting the interests of Florence and the Medici family: 'you should be the link to bind this city closer to the church, and our family with the city'. Although it is quite lucid, Lorenzo must have written the letter in a state of urgent unease, worn out by the illness to which he would succumb just a few days later, on 8 April 1492, never getting to see his son put his advice into action with so much zeal that he rose to the papal throne in 1513 with the name Leo X, one of the most celebrated of the Renaissance popes.

Raphael had already portrayed the Medici pope in the fresco *The Meeting between Leo the Great and Attila* (dressed as both his predecessor namesake and a cardinal). Shortly after, he was commissioned to design the cartoons for the tapestries for the Sistine Chapel. Finally, probably in the autumn of 1519, he wrote his famous letter to Leo, drafted with the aid of Baldassarre Castiglione, presenting his plan for cataloguing and preserving the ruins of ancient Rome. It was within the context of these cultural relations that the artist painted this superb portrait, dated to about 1518, in which the pope's attention seems to be turned to something outside the composition. Indeed, he has just raised his eyes from the illuminated manuscript that he was examining with a lens and turns his gaze to the room around him, which is defined by the stone architecture in the background and the window reflected in the knob on the chair back. Leo is surrounded by two cardinals who are also his cousins: on the viewer's left, Giulio de' Medici (the future Clement VII) and, on the right, Luigi de' Rossi, son of Maria, one of Lorenzo the Magnificent's older sisters. The peerless refinement of Raphael's hand renders the material aspects of the silks and velvets in a masterful tonal balance, as with the fur trim and engraved metal. This portentous image of the head of the Church and the family was sent in lieu of Leo, who could not travel to Florence, for the wedding banquet of Lorenzo di Piero de' Medici, duke of Urbino, and Madeleine de La Tour d'Auvergne. And the costly Bible, identified as the one decorated in the fourteenth century by the illuminator Cristoforo Orimina and commissioned by the queen Joan I as a gift to the French pope Clement VI

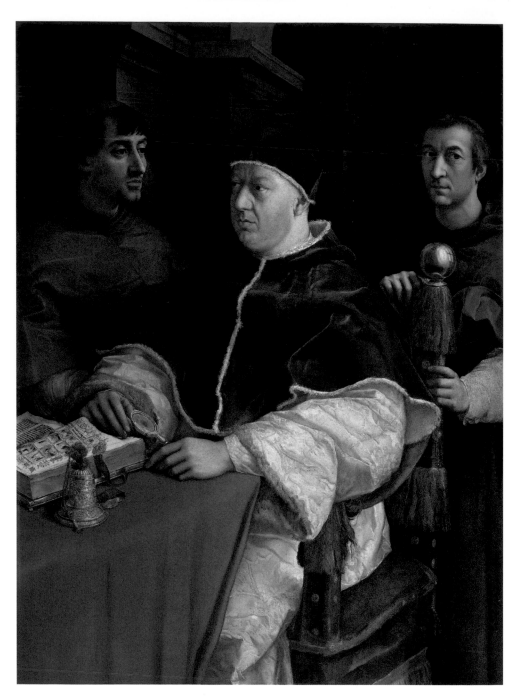

Raffaello Sanzio, *Leo X between two Cardinals*, 1518, oil on panel. Gallerie degli Uffizi.

(Pierre Roger de Beaufort) or one of his relatives, might have been an homage to the bride. It was certainly an apt choice for the portrait of the cultured Leo X, perhaps still mindful of his father's letter, which advised him, among other things, that his 'taste will be better shown in the acquisition of a few elegant remains of antiquity, or in the collecting of handsome books, and by [his] attendants being learned and well-bred rather than numerous'.

ALONE AGAINST THE LANDSKNECHT
GIOVANNI DALLE BANDE NERE (1498–1526)

A few months after he was born, Ludovico de' Medici's name was changed to that of his recently deceased father, Giovanni il Popolano, by his mother Caterina Sforza, lady of Forlì, who was one of the most important women in the Renaissance and even a match for the ruthless Cesare Borgia. Writing about the siege of the fortress of Ravaldino, Machiavelli reported that Caterina's enemies did not hesitate to display her captured children in an attempt to force her to surrender, but instead she lifted up her skirt and, 'pointing to her genitals', replied that she could simply make more. Giovanni inherited his mother's strong character. After a turbulent youth, he gathered around him a group of men who wanted to become soldiers and saw to their training, instilled them with discipline and provided their equipment, creating a host of modern soldiers, known for their speed on light horses, including agile Turkish mounts. Under Giovanni's command, these brave men advanced under his white-and-purple striped insignia, the stripes later turned black as a sign of mourning upon the death of his uncle Leo X; hence his nickname, 'dalle Bande Nere', which means 'of the black bands'. A leader on the battlefield, Giovanni headed the papal troops during the conflict that broke out after the formation of the League of Cognac, an anti-Habsburg coalition supported by Clement VII with the France of Francis I, followed by the march of the troops of Charles V south towards Rome. This army, made up of Spaniards, irregular Italian fighters and numerous German mercenaries known as Landsknecht, soon stopped being paid its salary, but they saw the opportunity to make up for it by plundering the riches of Rome. The passage of these mercenary troops, also driven by religious hostility, filled Northern Italy with terror and dread. Some of the seigniories chose to pay out large sums to save their lands, while Alfonso I d'Este provided the imperial troops with lethal falconets, light cannons of his own invention. Among the pope's allies, the marchese of Mantua, Federico II Gonzaga, betrayed him, allowing the invaders to pass, and Francesco Maria I della Rovere limited himself to defending Venetian territory. Unaware that the enemy possessed artillery, only Giovanni fought with courageous furore, but his leg was gravely injured during the Battle of Governolo, near Mantua. Pietro Aretino, who was in the city at the time, reported that in an attempt to save him, it was decided to amputate the gan-

grenous leg and they sought 'eight or twelve people to hold him down, during the violent sawing', but Giovanni refused, saying that not even twenty men would be enough, and he picked up a candle to provide light for the surgeon as he worked. A few hours later, he died, just twenty-eight years old.

The powerful portrait painted by Francesco Salviati, even though posthumous, expresses the impetuous knightly character of the captain. Through briskly applied bright hues and soft finishes, the fiery, quick gaze and features light up with the turn of the head, creating a palpable psychological tension. The suit of armour, modelled on the one belonging to Cosimo I, son of the sitter and patron of the painting, is also described in terms of its gleaming metallic coldness, but enlivened by quick touches of red, to infuse the figure with a powerful interior throb that matches Giovanni's personality.

THE POPE OF THE SACK OF ROME
CLEMENT VII (1478-1534)

Shortly after Giuliano's assassination in the Pazzi Conspiracy, it was discovered that he had an illegitimate child, Giulio, now just a few months old, who was then taken in and protected by Lorenzo the Magnificent. Giulio received a scrupulous education and made use of the support of his cousin, Leo X (with whom he is portrayed in Raphael's extraordinary triple portrait), who made him a cardinal in 1513. With a brilliant political career in service of the curia under his belt, he managed, not without fierce opposition, to secure the papal tiara during the 1523 conclave. Leo X had been succeeded by the severe Adrian VI, and it was hoped that the election of Clement VII would bring a new, enlightened cultural season to Rome. But black clouds were forming over the Eternal City, ready to unleash a storm capable of upending the new Medici pope, binding his memory to one of most devastating events in contemporary European history: the Sack of Rome. The relentless march of the troops of Charles V down the peninsula ended with an unreal morning under a blanket of fog (6 May 1527), when the troops flowed unchecked into the city centre, undefended due to the insufficiency of the pope's measures, who had wavered too long in the conviction that nobody would have dared to strike the principal city of Christianity, cradle of ancient culture. The chronicles written by those with the misfortune of being in Rome at the time, including illustrious names like the sculptor Benvenuto Cellini, who fought armed at Castel Sant'Angelo, go into great detail about the violent, even cruel, episodes they witnessed. They tell of killings, rapes, theft, derision, blackmail and violence of every kind inflicted even upon those who had sought refuge in churches and nuns

Francesco Salviati, *Giovanni dalle Bande Nere*, 1546–1548, oil on panel. Galleria Palatina. ▶

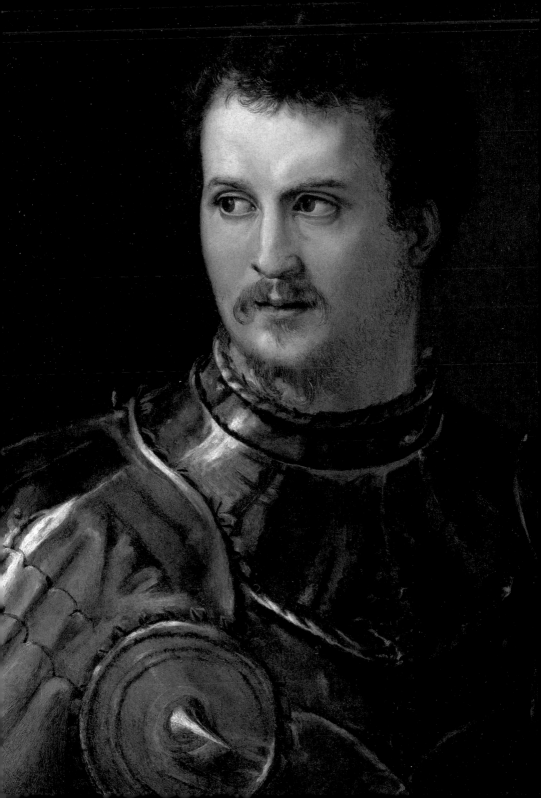

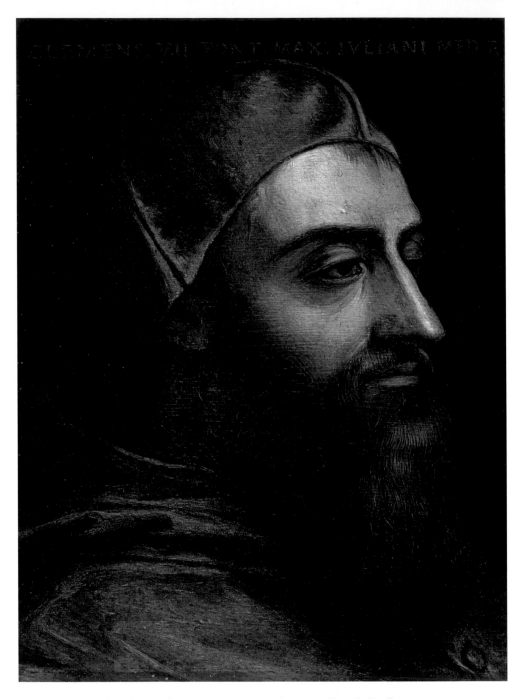

Bronzino and workshop, *Clement VII*, 1565-1569, oil on tin. Gallerie degli Uffizi.

in convents. Only the residences of the emperor's allies were spared havoc, which instead befell other splendid Roman homes, where furnishings, art collections and libraries of inestimable value were sacked or destroyed. The graffiti left by the Landsknecht on the frescoed walls of the Sala delle Prospettive at the Villa Farnesina and Raphael's Stanze at the Vatican vividly bring those dramatic days back to life. The savagery quieted down with the surrender of Clement VII, barricaded in Castel Sant'Angelo, but the imperial troops occupied the city for months, leaving behind a disheartened society and a decimated population. After these events, the pope decided to let his beard grow as a sign of mourning, and this is how he is portrayed in the small portrait by Bronzino, painted in oil on tin, a refined technique that renders the complexion and fabric especially vivid. Compared to the famous portrait at the Museo di Capodimonte, Naples, painted by Sebastiano del Piombo before the Sack, where the majesty of the powerful sitter – his gaze turned elsewhere as if absorbed in important, urgent thoughts – is accentuated by the spatial layout, the Florentine painting is instead dominated by a quiet fatigue that cannot even be alleviated by the dignity of the three-quarter pose, expressed with sophisticated compositional expertise. In Bronzino's solemn portrait, the pope is easily recognisable by the elegant lines of his face, his nose as straight as his mouth is shapely, but it expresses a private exhaustion, as if his body were worn down by the poisonous memories harboured in his soul. And so, the sophisticated handling of paint reveals not so much the passage of time on Clement's face as the passage of events.

THE MEDICI BANISHED FROM FLORENCE AND THEN THE DUCHY

On 4 June 1469, Clarice Orsini was received with great pomp at the family residence in via Larga, today known as Palazzo Medici Riccardi. Clarice, from an old, noble Roman family, had been carefully assessed by Lucrezia Tornabuoni and chosen to marry her son, the future Lorenzo the Magnificent. The first members of the Medici family who could boast noble blood, the couple's children grew up in that perfect Renaissance palace, frequented by Donatello, Benozzo Gozzoli, Michelangelo and many other artists and men of letters, including Poliziano who was the tutor of the firstborn, Piero de' Medici (1472–1503), later nicknamed the Fatuous. The political aptitude demonstrated by the younger brother Giovanni in his rise to the papal throne was lacking in Piero, who, taking over his father's public roles when he was twenty-one, did not stand out for any skills. Even the shrewd Medici cultural policy suffered a setback: in January 1494, Piero, later described by Michelangelo as 'insolent and intemperate' (as reported by Condivi in his biography of the artist), gave the young sculptor a miserable commission, asking him to make a snow statue in the courtyard of Palazzo Medici. In the autumn of the same year, the entry into Italy of the king of France, Charles VIII, headed to Naples to reclaim the

throne, shook the precarious equilibrium achieved by the Italian States during the time of Lorenzo. Piero, although he had not received an official post, met the French king in Sarzana and hastened to grant him use of its fortress along with the ones in Sarzanello and Pietrasanta, as well as the cities of Pisa and Livorno. The detractors of the Medici family reported, perhaps making it up, that Piero even wanted to kneel down before the invader to kiss his slippers. Florence was seething. The anti-Medici faction seized the opportunity provided by such ill-considered behaviour to banish the Medici from the city (a measure suffered by the family on more than one occasion over time, as with many other Florentine families) and reinstate the autonomy of the republic, which soon degenerated into a kind of theocracy subjugated by the charismatic Dominican friar Girolamo Savonarola. A complex, controversial figure, the friar from the monastery of San Marco had been called to Florence by Lorenzo as a preacher, but his invectives were soon turned against the lifestyle of the Medici as well. Savonarola championed moral reform, rejection of luxury and embrace of the rigorous behaviour necessary for saving oneself from divine punishment, prophesied as imminent and seen by many as taking shape in Charles VIII's invasion. Savonarola's supporters, called *piagnoni* ('weepers') by the *arrabbiati* (the 'enraged', a pro-aristocratic faction), who often got carried away by the rigid aspects of a complex philosophical way of thinking, were the champions of what went down in history as the 'bonfire of the vanities' (7 February 1497), in which countless mirrors, embellishments, embroidered garments and fabrics, jewels, illuminated manuscripts, paintings and other works of art were burnt, forever lost. The same year as the most famous of these bonfires, Savonarola was excommunicated by the Borgia pope Alessandro VI, but he paid little heed, defiantly continuing his activity. However, fear concerning the consequential possibility of a papal interdict on the city of Florence, which would have interrupted trade with the rest of the Christian world, spread. Savonarola's hair-splitting refusal to submit himself to the trial of fire publicly demanded of him by a Franciscan friar and the strenghtening of the Palleschi faction (pro-Medici) ended up marring his prestige, and he was in the end hung and burned on a pyre in Piazza della Signoria on 23 May 1498. The impact of the friar's magnetic personality on different layers of Florentine society can also be measured looking at his influence on artists. While the painter Baccio della Porta's association with Savonarola was his reason for taking the habit with the name Fra Bartolomeo, in the case of Sandro Botticelli, described by his contemporaries as lively and light-hearted, the apocalyptic preaching was ruinous. Indeed, Vasari reported in the *Lives*: 'The best of these that is to be seen by his hand is the Triumph of the Faith effected by Fra Girolamo Savonarola of Ferrara, of whose sect he was so ardent a partisan that he was thereby induced to desert his painting, and, having no income to live on, fell into very great distress. For this reason, persisting in his attachment to that party, and becoming a *piagnone*, he abandoned his work; wherefore he ended in his old age by finding himself so poor, that if Lorenzo de' Medici … had not succoured him the while that he lived, as did afterwards his friends and many excellent

men who loved him for his talent, he would have almost died of hunger.' Piero the Fatuous died in exile, but his son Lorenzo was able to return to Florence in 1512, since Pier Soderini, gonfalonier of the Florentine republic for life, had fled the city, guilty of having granted use of Pisa, a city within the Florentine sphere of influence, for the convocation of the council by the same name, hostile to Julius II. The energetic pope, born Giuliano della Rovere, responded by placing Pisa and Florence under interdict and forming an alliance with the Medici. Nevertheless, in 1516, Lorenzo received the papal investiture for the duchy of Urbino, to the detriment of the Della Rovere family. Urbino was not under Medici rule for very long: Lorenzo de' Medici died on 4 May 1519. He is leid to rest in the New Sacristy designed by Michelangelo for the Medici church of San Lorenzo, watched over by the famous marble sculptures of *Dawn* and *Dusk*, in a tomb topped by a portrait statue that portrays him in a contemplative pose. The pendant tomb, with sculptures depicting the other phases of the day, *Night* and *Day*, holds the remains of Giuliano, duke of Nemours, Lorenzo the Magnificent's youngest son. The illegitimate sons of both, Alessandro and Ippolito de' Medici, were just about to appear on the Florence scene.

THE FIRST DUKE OF FLORENCE
ALESSANDRO (1510/1512–1537)

The two Medici popes, who became head of the family one right after the other, placed their hopes for the line in Alessandro and Ippolito, cousins of the same age locked in bitter rivalry since childhood. Clement VII spared no effort, procuring Ippolito (1511–1535) an ecclesiastic career as prestigious as it was unwanted, and providing Alessandro with feuds and titles. The small portrait of Alessandro, probably by the hand of Bronzino, highlights the marked features and dark complexion that earned him the nickname 'Il Moro' (the Moor), inherited from his mother, a woman of humble origins who many scholars believe was not the lover of Lorenzo, duke of Urbino, but rather Cardinal Giulio de' Medici (later Clement VII), hence the uncertainty over his year of birth.

The painting is one of the most beautiful in the small series of portraits on tin made by Bronzino, his student Alessandro Allori and their respective workshops. The works depict the main members of the Medici family, up to the children of the grand duke Cosimo I. The handling of paint but also the spatial structure of the figure, which together with the distribution of shadows on the face and the glimmers on the chain mail suggests the sitter's quickness of movement, point to the hand of the master as much for the invention as for the execution of the work. Raised at the papal court, Ippolito and Alessandro were sent to the Signoria in Florence in 1525, but the Medici were again sent away after the Sack of Rome. Two years later, Clement VII and Charles V mended fences. The pope was provided with imperial troops to attack Florence (1530) and regain control of the city, this time making it a principality, with

Alessandro being given the title of duke – as well as the hand of a illegitimate daughter of Charles V, Margaret of Austria.

The meaning of the various elements of Vasari's full-length portrait of Alessandro de' Medici was originally explained in verse on the frame, which is unfortunately lost. Luckily, Vasari also explained his choices in a letter to the patron, Ottaviano de' Medici, probably serving as intermediary for his powerful relatives: 'His white armour shines, as should the mirror of the prince so that his people can be reflected in him. . . . He is seated, showing that he has taken possession and holding the baton of dominion, all gold, to support and command as prince and captain. . . . The round seat he sits upon, having no beginning or end, shows his perpetual reign.' Vasari continues, explaining every detail: the herms on the feet of the stool 'are his populace, which, led in accordance with the will of he who commands them, have neither arms nor legs', while the red cloth symbolises the spilt blood of the enemies of duke and, since part of it is draped over Alessandro's leg, 'shows that those of the Medici house were also struck with blood, from the death of Giuliano and the wounds of Lorenzo the Elder'. On the left, the truncated Medici tree is flowering again while the duke's helmet 'smoking on the ground, is the eternal peace that, proceeding from the head of the prince through his good government, fills his people with happiness and love'. The duke is seated in a ruined building with columns, illuminated by light from a window that reflects on the helmet. He is looking out towards Florence, which can be glimpsed in the distance through a crumbling opening in the wall; the dome of the Florence Cathedral is particularly recognisable.

In the fine portrait by Titian, Cardinal Ippolito, identified by the brooch pinned to his hat, which is inscribed with the motto inter omnes beneath the emblem of comet, is wearing a Hungarian-style jacket beneath which we can make out the shape of a protective cuirass. Titian, exceptional portraitist that he is, calibrated his technique to describe the unusual garment in full detail and at the same time dissolve the fabric through the use of soft hues, creating a gradual effect of delicate evanescence that directs the viewer to the faithful description of the clothing and then lets the natural complexion, sharp features and penetrating eyes, the focal point of the resolute expression, emerge. The portrait of Ippolito de' Medici surpasses pure physiognomy to vividly express the psychology of the sitter, who was forced to wear the cardinal's cap but longed to be a military commander, comfortable in his condottiere attire, his hand on the eastern-style hilt ready to unsheath the weapon. The cardinal led a lavish life in Rome, surrounded by an extravagant court of at least 300 individuals, but his bitterness over being passed over for the throne in favour of Alessandro never left him. The Moro, however, was not duke for long: his cousin Lorenzino de' Medici, from the Popolani branch, also known as Lorenzaccio, murdered him on the night of Epiphany in 1537, a mocking fate, since the Three Magi were among the protectors of the Medici

Bronzino and workshop, *Alessandro de' Medici called il Moro*, 1565-1569, oil on tin. Gallerie degli Uffizi. ▶

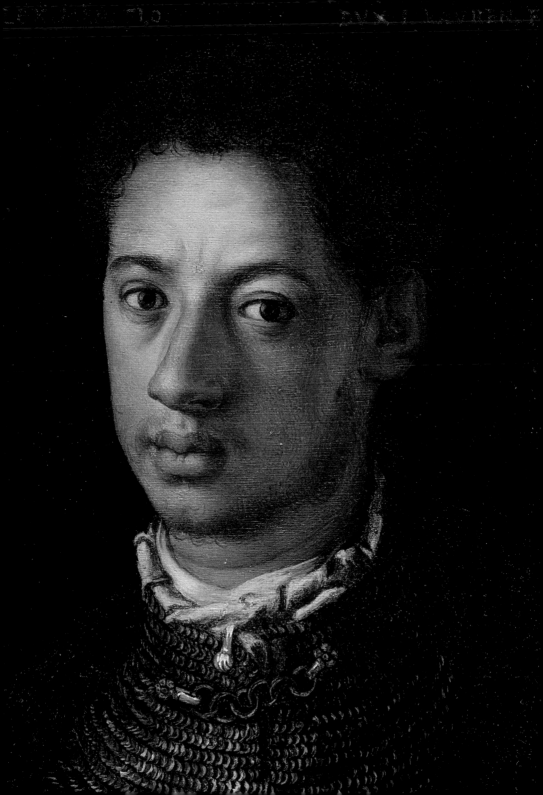

family. Lorenzino, a cultured man in contrast to the arrogant Alessandro, might have been influenced by his readings on tyrannicide in antiquity. He later wrote a celebrated *Apologia*, a lofty text written in defence of the values of liberty and justice that had in-

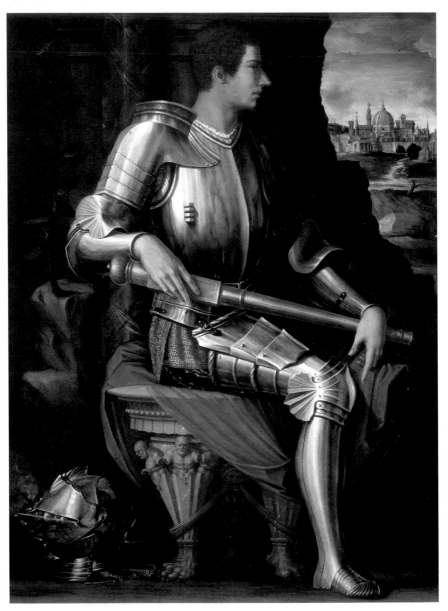

Giorgio Vasari, *Alessandro de' Medici called il Moro*, 1534, oil on panel. Gallerie degli Uffizi.

spired his act. The murder of Alessandro, who held the incongruous hereditary tile of 'Duke of the Florentine Republic', chosen to avoid offending the susceptibility of the other government authorities, triggered a major institutional crisis.

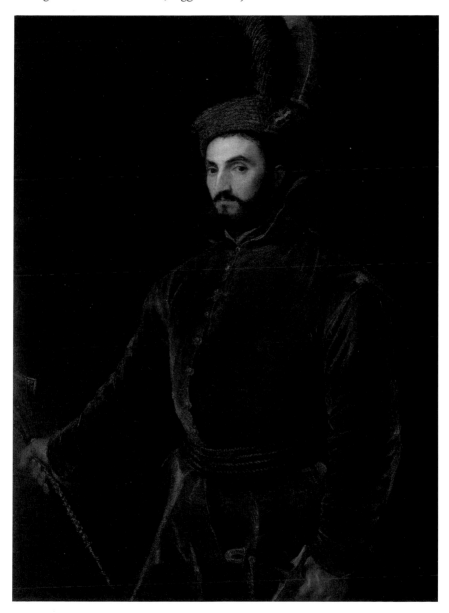

Tiziano Vecellio, *Ippolito de' Medici*, 1535, oil on canvas. Galleria Palatina.

QUEEN OF FRANCE AND MOTHER OF THREE KINGS
CATHERINE (1519–1589)

Orphaned just a few days after her birth, Catherine de' Medici, daughter of Lorenzo di Piero de' Medici, duke of Urbino, was raised by her grandmother Alfonsina Orsini, under the protection of Leo X and Cardinal Giulio de' Medici. The latter conducted the delicate negotiations that led to her marriage to the second son of Francis I, Henry of Valois (1519–1559). Their wedding was held in Marseille on 28 October 1533, officiated by Giulio, who was now Clement VII. When the heir to the throne died prematurely, the young duchess's husband became the new dauphin of France and then King Henry II, but Catherine's position at court remained marginal for a long while, due to her sterility during the first ten years of their marriage and the awkward presence of Diane de Poitiers, her husband's influential mistress, who was twenty years his senior and captivated him with her beauty and personality for his whole life. Henry died in 1559, forty years old, from wounds suffered during a tournament. Catherine forced Diane to return part of the wealth she had been given, sent her away from Paris and became, at least formally, regent to her adolescent son Francis II (1544–1560). When Francis died the next year, the throne passed to his ten-year-old brother (1550–1574), who reigned as Charles IX. When he died without an heir as well, the throne fell to Catherine's favourite son, Henry III (1551–1589), for whom the queen mother had already procured the Polish throne. Catherine de' Medici brought many aspects of the refined Florentine Renaissance culture to France, fostering its fusion with the local one, but contemporary propaganda against the Valois described her mainly as a ruthless manipulator, poisoner and obsessed with the astrological predictions of Nostradamus. The political authority of the queen was unprecedented in France. A heavy burden, not least due to the long religious wars between Catholics and Huguenots that were devastating the country. Reconstructing the weight of her influence on her children's decisions is complex, one glaring example being the order to massacre the Huguenots gathered in Paris for the 'peacemaking' wedding of the Catholic Margaret of France, Catherine's daughter, to the Protestant Henry of Navarre. The massacre of thousands of people, known as the Massacre of St Bartholomew's Day, began after sunset on 23 August 1572, and continued for days across France. Since none of Catherine's sons had male heirs, the French throne passed to the Bourbons through Henry of Navarre, who agreed to convert to Catholicism in order to obtain it – he is the one attributed with the phrase 'Paris is worth a Mass' – and then, his marriage to Margaret annulled, married Marie de Médicis.

In the portrait of Catherine de' Medici, an inscription on the fabric around her shoulders identifies her as the queen of France. And so, the dating of the work oscillates between Henry II's rise to the throne and his death, after which Catherine

French School, *Catherine de' Medici*, 1547–1559, oil on canvas. Galleria Palatina. ▶

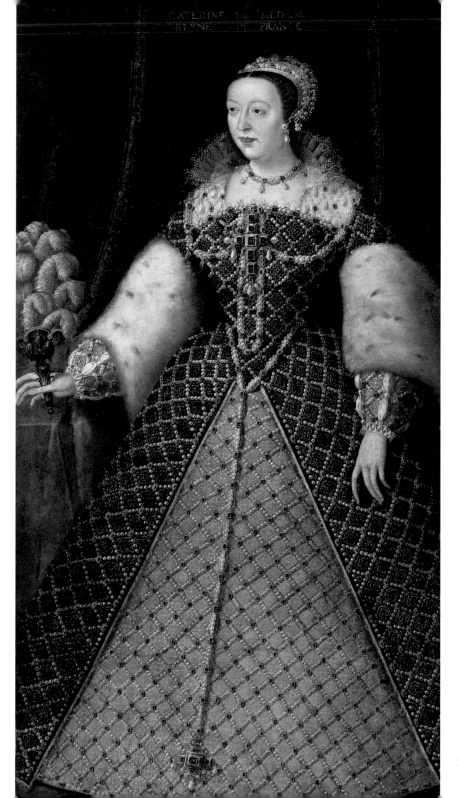

always wore black. Her highly refined dress, complete with a surcoat and ermine sleeves, is entirely covered with a stunning geometric pattern of pearls and diamonds set in gold, with more diamonds embellishing her cap, belt, cross and necklace. Some of the pearls are enormous and pear-shaped, and probably included the seven that were given to Catherine by Clement VII for her wedding, which the queen then gave to her daughter-in-law Mary Stuart, and then passed to the English crown after Mary's beheading, ordered by her cousin, Elizabeth I, queen of England.

LORDS OF FLORENCE AND TUSCANY

COSIMO I (1519–1574)

When Duke Alessandro was murdered, dying without a legitimate heir, the Senate of the Forty-Eight, one of Florence's most prestigious magistracies, found it opportune to elect as his successor Cosimo de' Medici, the only son from the marriage of Giovanni delle Bande Nere, from the cadet line of the Popolani, and Maria Salviati, the granddaughter of Lorenzo the Magnificent. The Florentine institutions thought that they would be able to easily manoeuvre the seventeen-year-old, but the vigorous Cosimo, who combined two Medici bloodlines, immediately showed his resoluteness, defeating and hanging the Florentine exiles led by the Strozzi who had challenged his role as duke in the Battle of Montemurlo (1537). With the passage of time, power became increasingly concentrated in his hands alone, as observed by Benedetto Varchi in his *Florentine Histories*: 'Nor is anyone surprised that I always say that Cosimo, not the state nor the Quarantotto nor the councillors, but Cosimo alone ruled everything. Nor was anything said or done, no matter how big or small, without him saying yes or no.'

Bronzino was commissioned to paint this fine portrait of Cosimo I in armour, twenty-five known copies of which, with variations, are found in museum collections across the world: 'The Lord Duke, having seen … the excellence of this painter … caused him to paint a portrait of himself, at that time a young man, fully clad in bright armor, and with one hand upon his helmet'. Vasari's words (in particular his reference to 'bright armor'), highlight the painter's skill in describing the variations of light on metal, embellished with decorative motifs including a kind of collar with the Medici coat of arms on his chest, by means of a cold palette and sophisticated fusion of cool hues applied with smooth brushstrokes. The 'hand upon his helmet' is a display of bravura Vasari was right to point out: well-shaped and smooth, the hand lightly rests upon the helmet, becoming one with it in the reflection. Scholars have noted that the splendid armour decorated with red ribbons, incised with the fineness of a gem, is like that worn by Charles I in a lost portrait by Titian, known through an engraving by Giovanni Britto, and that the cuirass must have been used

Bronzino, *Cosimo I de' Medici*, c. 1543, oil on panel. Gallerie degli Uffizi. ▶

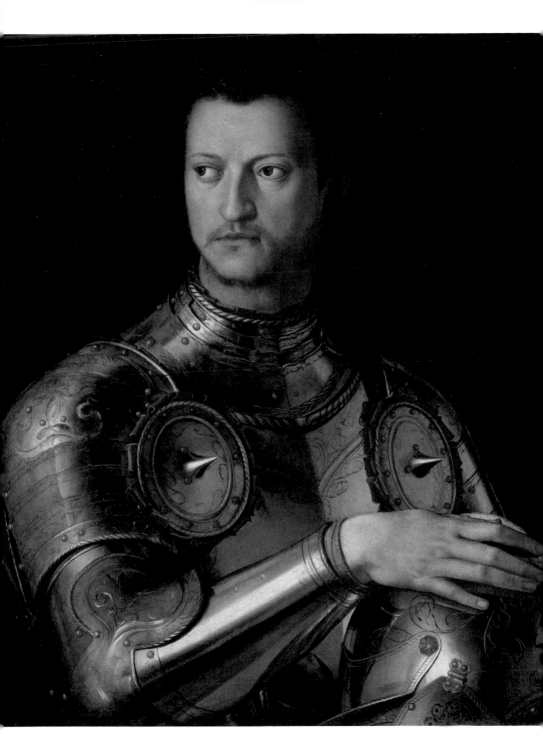

as a model by Francesco when he painted his portrait of Giovanni dalle Bande Nere. These shrewd choices doubly legitimise the young duke, placing him on axis with the military skills of his father, well-known and praised in Florence, and the representation of the emperor who had confirmed his ducal title. Cosimo looks into the distance, with a calm but at the same time authoritative and at-the-ready expression, a pacified Mars who has laid down his arms but is prepared to immediately take them up again if necessary.

Bronzino's painting is so well conceived one could say it is prophetic: Cosimo ruled as duke of Florence, and then Siena, with authority, commitment and firmness, obtaining the title of Grand Duke of Tuscany from Pius V in 1569. He implemented numerous reforms, handling every aspect of public administration, a change noticeable in the city in part due to the construction, next to what was known at the time as the Ducal Palace and soon after became the Palazzo Vecchio, of the Uffizi (administrative offices), the design of which had been entrusted to Vasari in 1560. Under Cosimo I, Florence had a proper court for the first time, and Medici patronage, the main propaganda tool, was intensely focused on the portrait genre, leaving a few true masterpieces to posterity.

BRONZINO'S INVENTIONS FOR STATE PORTRAITURE
THE FAMILY OF COSIMO I AND ELEONORA OF TOLEDO

Eleonora of Toledo (1522–1562) and Cosimo were married by proxy in Naples. On 29 June 1539, the bride was welcomed in Florence with lavish celebrations. Eleonora, born into a noble Spanish family, was the daughter of Pedro Álvarez de Toledo, viceroy of Naples for Charles V. The emperor spared no effort to procure Cosimo a pro-Spanish marriage, after having refused to allow him to marry Margaret of Austria, the widow of the first duke of Florence, Alessandro. Even though arranged, Eleonora and Cosimo's marriage was a happy one: both young, beautiful, energetic and devoted to family, their bond was sincere. Insofar as possible, Eleonora accompanied her husband on his travels and the couple's good rapport is confirmed by an observation made by the Venetian ambassador to the Florentine court, Vincenzo Fedeli, who wrote in 1561: Cosimo, 'after becoming prince, never conversed with any woman other than the duchess his wife'. Don Pedro had tried to marry Cosimo to his elder daughter Isabella, but the duke, warned that the candidate was 'ugly and her brain the laughingstock of Naples' (letter from Angelo Niccolini, Medici agent in Naples, to the court secretary Ugolino Grifoni, 4 January 1537), insisted on marrying the seventeen-year-old Eleonora, with whom he had numerous children.

Bronzino was the right painter for celebrating the legitimacy of the power conquered by the new duke through portraits of his family. Trained under Pontormo,

Bronzino, *Eleonora of Toledo with her son Giovanni*, 1545, oil on panel. Gallerie degli Uffizi. ▶

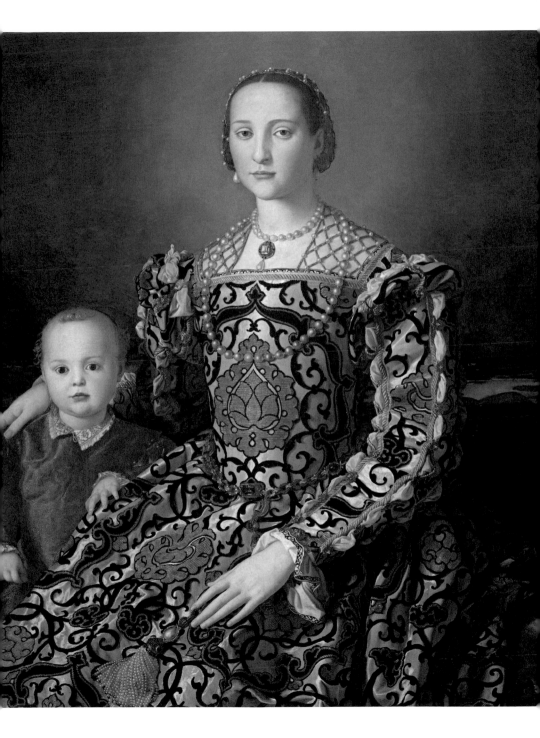

Bronzino had a multi-faceted personality: a refined, imaginative painter, he also devoted himself to poetry, sometimes composing licentious sonnets and burlesque verses and often deriding friars and monks. One of his masterpieces is the Chapel of Eleonora in Palazzo Vecchio, decorated for the duchess's private devotion. But he was mostly used by the Medici as a portraitist, fixing the canons for the circulation of effigies of the members of the ruling family.

The famous painting of Eleonora of Toledo with her son Giovanni is a striking example of the political function of official portraiture under Cosimo I and a compendium of the original solutions conceived towards that end by the painter. The duchess is seated on a cushion outdoors, dominating the countryside in the background. The oppressive sky, deep cobalt in hue, prevents us from locating her in a recognisable space, instead creating an unreal, unreachable dimension in which the woman stands out sovereign. The regular beauty of her face supports a hieratic serenity. Her porcelain complexion seems to glow from without and even lighten the sky behind. Her composed pose, together with the display of wealth, expresses this woman's rank, a young mother who had already ensured the dynasty four of the children she would bring into the world. The duchess's clothing plays just as much of a leading role in the portrait, simultaneously displaying the wealth of the Medici house and the splendour of the fabrics produced in Florence, a concrete result of Cosimo's good government, his policy having aided the recovery of the Florentine textile industry. Eleonora was passionate about textiles, and even hosted a personal weaver in her apartments at Palazzo Vecchio, who slept next to the looms, probably to protect her work from 'industrial espionage'. The fabric has a white silk satin background with black Moorish arabesques and pomegranate motifs in gold *bouclé* brocade. The Spanish-style square neckline is attached to golden braiding embellished with pearls that covers her shoulders. Pearls also decorate the cap that holds her hair. Her sleeves are held together by dozens of gold pins, revealing puffs of the fine shirt beneath with embroidery at the wrists. Like the Medici coat of arms that stands out on Cosimo's chest in Bronzino's portrait of him in armour, Eleonora's midriff is emblazoned with a large stylised pomegranate, a well-wishing symbol of fertility and the emblem chosen by Empress Isabella, wife of Charles V. Against this elaborate fabric, the pearls and table-cut diamond stand out for their whiteness, while her waist is decorated with a gold-link belt embellished with rubies, diamonds and other precious stones, ending with an unexpected tassel of small strung pearls. These extremely fine, never flashy, jewels are of a graceful elegance that complements Cosimo's governmental choices, geared towards development of the principality but shunning ostentation and vulgarity. The goldsmith's art had reached dizzying technical and artistic heights in Florence. Exceptional artisans and great artists worked for Cosimo I and Eleonora, including Benvenuto Cellini, who even complained in his biography about receiving too many commissions for jewellery: 'The Duchess was paying me inestimable favours, and wanted me to work only for her, and devote myself to neither Perseus nor anything else.' Eleonora's only

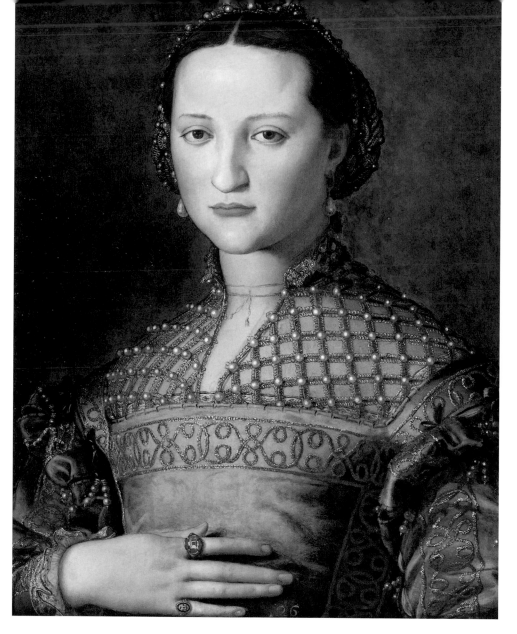

Bronzino, *Eleonora of Toledo*, c. 1543, oil on panel. Prague, Národní Galerie.

deviation from regal behaviour is her affectionate gesture towards her son Giovanni, about two years old at the time, who reciprocates, resting his small hand on her dress. The pose was actually carefully studied to make the duchess look like a modern Cornelia who, although aware of the value of what she is wearing, presents her

son as her most precious jewel: since while the Medici could buy fabric and baubles, it was through her that the dynasty ensured its future. The eloquent authority of Bronzino's invention was so effective that for two centuries the grand duchesses of Tuscany had themselves portrayed like Eleonora, with their sons by their sides. The Serie Aulica includes a posthumous portrait of Joanna of Austria and her son Filippo painted by Giovanni Bizzelli in 1586 and a portrait of Maria Maddalena of Austria and her young son Ferdinando painted by Justus Sustermans (1622–23). Bianca Cappello also chose this composition for one of her portraits with her son Antonio, now in the collection of the Dallas Museum of Art, in which the painter shows the little boy offering flowers to his mother.

Eleonora bought Palazzo Pitti to make it the new residence of the ducal family. Cosimo, wanting the palace on the left bank of the Arno to be connected to Palazzo Vecchio, commissioned Vasari to build the elevated passageway known as the Vasari Corridor, a project completed in record time, as Vasari himself reported in his *Ricordanze*: 'I recall that on 1 August of that year [1565], Duke Cosimo asked me to build the enclosed corridor that starts at Palazzo [Vecchio], goes above the offices [Uffizi], Lungarno and above the Ponte Vecchio and Santa Felicita and goes down from [Palazzo Pitti] to the Pitti gardens ... what one didn't think could be completed in five years was completed in five months.' Today, Palazzo Pitti is home to the Treasury of the Grand Dukes (formerly known as the Silver Museum), a splendid collection that spurs us to wonder what has survived of the fabulous fabrics and jewels worn by Eleonora of Toledo in her portraits. The answer is in the archives, in the lists of the Guardaroba Medicea, inventories and wills, documents that clarify that

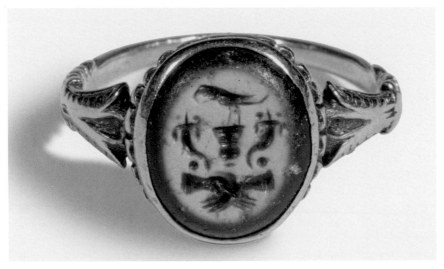

Florentine goldsmith, ring with ancient engraved stone, mid-16th century, chalcedony and gold with traces of enamel. Palazzo Pitti, Tesoro dei Granduchi.

the princes of the House of Medici house had objects of exceptional value at their disposal but that these, the jewellery in particular, remained the property of the dynasty and were managed by the firstborn son, although they could be formally given as gifts within the family. Over time, therefore, the gold links, pearls and gems were dismantled and recomposed to create new ornaments. Two objects, however, have come down to us in their original state and are therefore especially valuable: a dress in red velvet, preserved at the Museo Nazionale di Palazzo Reale, Pisa, and a gold ring with an engraved stone. The dress, Spanish in style and the bright red colour of which could be worn only by nobility, in accordance with a sumptuary law issued by Cosimo I in 1562, has a train that was folded up inside and stitched to adapt the dress to the statue of the Madonna it was given to. It unquestionably came from the court milieu, although it is not possible to determine whether or not it was ever worn by Eleonora of Toledo. What we know was long used by the duchess is a gold ring set with an ancient, probably Roman onyx stone that was found in her tomb during the recognition of the Medici tombs in 1857. The stone is incised with the motif of the *dextrarum iunctio* (two clasped right hands, a gesture of the marriage pact since antiquity) topped by two cornucopia and a vase with a bird standing on top of it, auspicious for a fruitful union. It is the same ring that is shown on Eleonora's finger in the half-bust portrait by Bronzino now at the Národní Galerie, Prague. The duchess's attachment to this piece of jewellery must have been known, as it was not returned to the Medici treasury. It remains today eloquent testimony to her love for her husband.

THE LITTLE PRINCES OF FLORENCE

Bronzino's portraits of the young princes follow the same logic that underpins the portraits of the adults. In the portrait of Maria de' Medici, the duke and duchess's eldest child, our attention is drawn by the intense blue-grey eyes, as sparkling as the diamonds in her earrings, of this ethereal little girl, frozen in the detachment of the pose. Ostentatiously aware of her role, she is portrayed frontally, painstakingly described in appearance and clothing – the rendering of the dark green (a costly hue coveted at the time) velvet is admirable – and yet distant and unreachable due to the dignity of her impassable aloofness. The beautiful Maria (1540–1557), who died of spotted fever when she was seventeen, was engaged to the future Alfonso II d'Este, duke of Ferrara, who was then given in marriage to another of Cosimo's daughters, the very young Lucrezia (1545–1561). Urgent political matters took the groom to the French court a few days after the wedding and Lucrezia remained in Florence under the close watch of her mother. When his father Ercole II died in 1559, Alfonso made his return and the next year rejoined Lucrezia. The duchess did not have the opportunity to settle into life at the lively Ferrara court since she died in April of 1561.

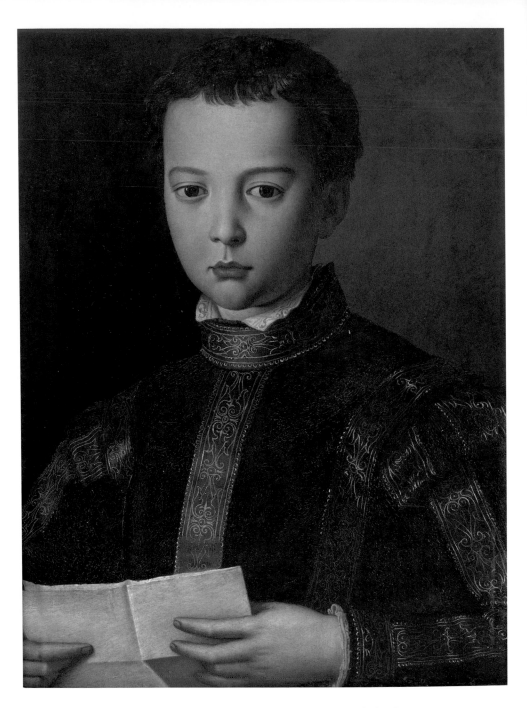

Bronzino, *Francesco di Cosimo I de' Medici*, 1551, oil on panel. Gallerie degli Uffizi.

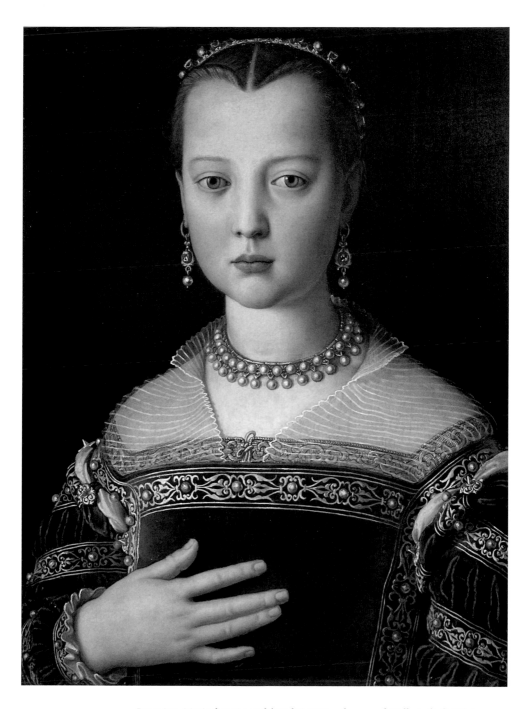

Bronzino, *Maria di Cosimo I de' Medici*, 1551, oil on panel. Gallerie degli Uffizi.

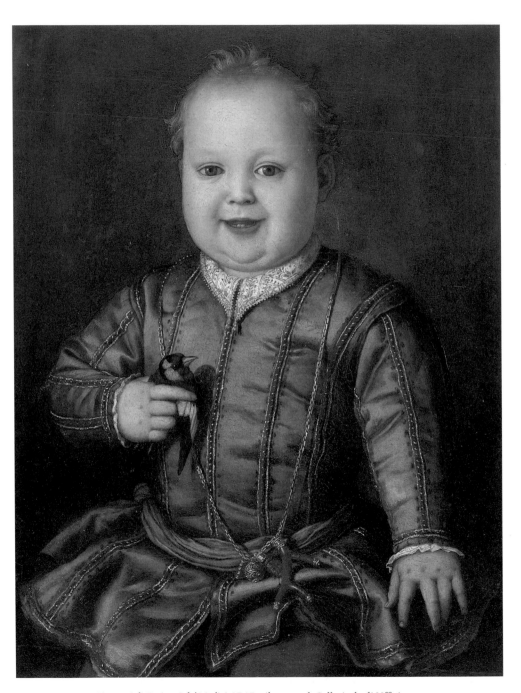

Bronzino, *Giovanni di Cosimo I de' Medici*, 1545, oil on panel. Gallerie degli Uffizi.

Her brother Francesco, heir to the throne, was also painted by Bronzino when a child, but already sunk into his future role, intent on reading a document even though he was only ten years old. Bronzino's vibrant hues and impalpable veils of paint describe as much the costly black velvet, embellished with brown inserts with gold decorations, as the lively, watchful gaze of the prince, heralding, along with the gesture, his judicious nature and aptitude for governing, at least in the intentions of the painter, who was satisfying the desires of the patron.

The eighteen-month-old toddler with brand-new teeth and fine downy hair expertly rendered by Bronzino is instead plump and smiling: this is Giovanni, the very same who the painter later portrayed standing composed next to his mother Eleonora. This painting was in fact a private work and here the little one's joyful spontaneity is left unchecked. Giovanni (1543–1562), the second-born male child, was destined from birth for an ecclesiastic career, in the hope that he would emulate the eponymous son of Lorenzo the Magnificent, who became pope. This might be why the child is playing with a goldfinch, the blood-red plumage of which around the beak evokes the tradition according to which this bird was injured trying to remove the thorns from the crown of the crucified Christ. The piece of coral is also a Christological reference, although pendants of this style and material were popular at the European courts of the time, when infant mortality was frequent, and one hoped to ward off ill luck with these jingling amulets.

THE BELOVED DAUGHTER
BIA (1536?–1542)

Before his marriage to Eleonora of Toledo, Cosimo had a daughter, Bianca, nicknamed Bia, who he loved dearly and kept with him at court, looked after by her grandmother Maria Salviati. Bronzino, as we learn from Vasari in his *Life* of the painter, 'portrayed also the little girl Bia, natural daughter of the Duke', who unfortunately died in February 1542 when she was just five years old. Some scholars think that Bronzino used the wax death mask that fixed the features of the little girl for his portrait of Bia de' Medici, which would explain the noticeable immobility of the face of this small child, described in the papers as exuberantly joyful. The white silk dress and pearls reference the little girl's name, while the medallion she wears around her neck bears a portrait of her father in profile, as he was portrayed by Pontormo, modelled on ancient coins. The child is sitting upright on a carved armchair, the arm and backrest of which emerge from the shadows, although this positioning in space does not pull her away from the unreal and distant dimension into which she is transported by the opaque lapis lazuli-hued background. When Bia died, her father Cosimo gave the cash dowry reserved for this beloved little girl to another illegitimate child of the House of Medici, Giulia di Alessandro 'il Moro'.

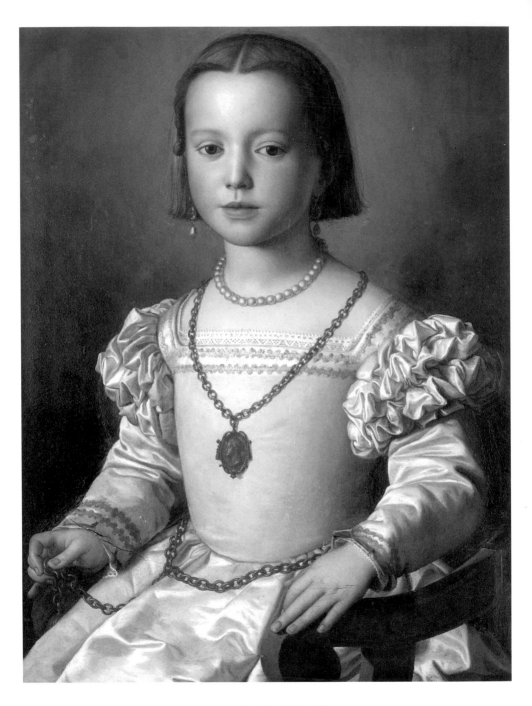

Bronzino, *Bia de' Medici*, 1542, oil on panel. Gallerie degli Uffizi.

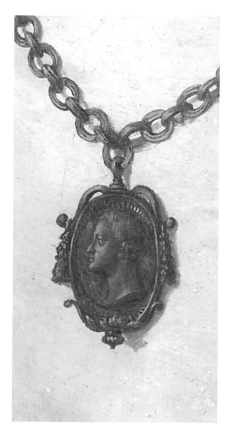
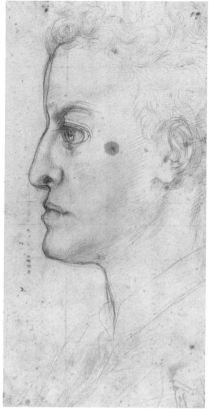

Bronzino, *Bia de' Medici* (detail), 1542, oil on panel. Gallerie degli Uffizi.

Pontormo, *Cosimo I in profile*, 1537, stylus, black stone, white chalk on squared paper.
Gabinetto Disegni e Stampe degli Uffizi, no. 6528 verso.

The frequent travel of the Medici court through parts of Tuscany still unhealthy at the time was in many cases the cause of deaths in the family of Cosimo I. As noted above, the beautiful firstborn Maria died unmarried when she was seventeen. Her sister Lucrezia, married at fourteen to Alfonso d'Este, survived until she was sixteen. On 20 November 1562, the brilliant ecclesiastic career of nineteen-year-old Giovanni, cardinal since he was fifteen, was cut short by malarial fever, the umpteenth blow for her mother Eleonora of Toledo, already weakened by the tuberculosis that led her to the tomb a few days later, closely followed by her son Garzia, he, too, from malarial fever. In that dramatic winter of 1562, Cosimo I suffered the latter three deaths in the span of little over a month. Life struggles that probably influenced his decision to pass the weight of government to his son Francesco in 1564, retaining the ducal title and the right to intervene in issues of particular importance.

In 1570, Cosimo made the trip to Rome, despite being weakened by the stroke he had suffered two years earlier, to be crowned Grand Duke of Tuscany, a title granted him the year before by Pius V. The pope also urged him to legalise, through marriage, his relationship with Camilla Martelli, who had taken the place of her cousin Eleonora degli Albizi as official mistress of the grand duke: the latter was also young and beautiful but incapable of winning over the sympathies of the court and Eleonora of Toledo's children. After a couple of years in this role, Eleonora degli Albizi was married off to Carlo Panciatichi, who was compensated with a cash incentive and a pardon for a murder for which he had been exiled from Florence. Whereas Camilla Martelli contracted a morganatic marriage with Cosimo, without ever becoming grand duchess but ensuring that she would be well provided for economically, even for the future, with gifts and revenues that would then pass to their daughter Virginia. In spite of all this, the very same day Cosimo died, his widow was doomed by the new grand duke to a cloistered life in the convent of the Murate: a fate not unlike that of her cousin Eleonora, who was confined to a convent when she was thirty-five, dying there in her nineties.

THE BLACK SHEEP AND 'STAR OF THE HOUSE OF MEDICI'
PIETRO (1554–1604) AND ISABELLA (1542–1576)

Of the numerous children born to Eleonora of Toledo and Cosimo I, those that survived their father included not only the firstborn son Francesco but also the brilliant Isabella, Cardinal Ferdinando and the black sheep of the family, Pietro de' Medici. A self-important, arrogant, violent spendthrift who loved weapons more than the military career that had been laid out for him and was given to excess in all his relations, Pietro travelled frequently and lived mostly in Spain (where he was known as don Pedro), causing trouble wherever he went. In the fine full-length portrait painted by Santi di Tito during one of the rare Florentine sojourns of the couple's youngest son, he is indeed portrayed in Spanish dress, and even his pose is derived from popular Spanish models. The painting is splendidly concentrated on a palette of just three hues – dark green, gold and ochre – combined to create both the warm atmosphere of the room and the light that strikes the satiny fabric of the curtain. Over his padded black taffeta jacket, Pietro wears a curious garment, composed of alternating strips of leather and black passementerie joined together with silk cord, fastened at the neck and at the waist, leaving an opening down the front. The sleeves and breeches are also made of strips of fabric, decorated with a refined fish-bone pattern: a sophisticated outfit completed by a 'side-sword', typical of procession, rather than battle, clothing. The portrait reveals the slight build of this problematic member of the Medici family, a characteristic that did not prevent him, on 9 July 1576 at villa at Cafaggiolo, from killing, probably by strangulation, his wife and cousin Eleonora Álvarez de Toledo, known as Dianora, with the excuse of pos-

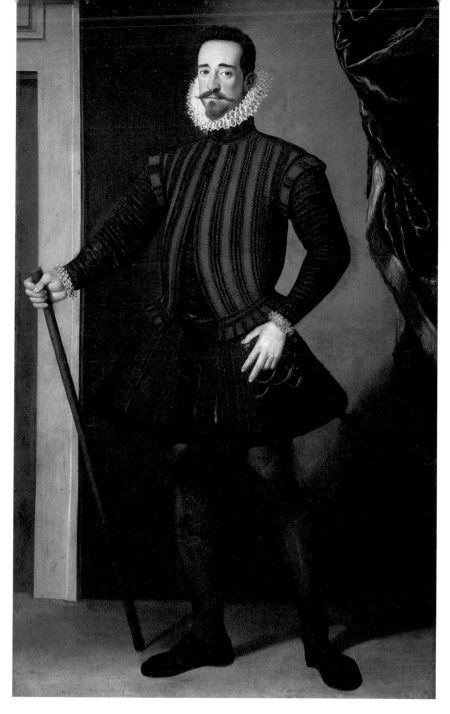

Santi di Tito, *Pietro di Cosimo I de' Medici*, 1586, oil on canvas. Gallerie degli Uffizi.

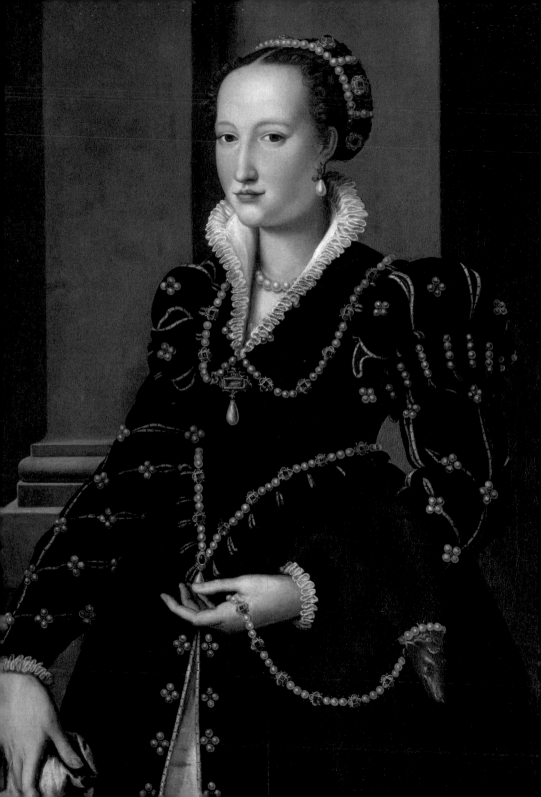

sible adultery, and certainly guided by his violent nature. We learn from the Medici papers and the dispatches of the Florentine ambassadors that Pietro's behaviour was a constant thorn in his brothers' side. When he died, Ferdinando had to pay off his many creditors and help his illegitimate children.

A few days after the murder of Dianora, on 16 July 1576, Isabella de' Medici, a cultured, lively woman who was given in marriage to Paolo Giordano Orsini, duke of Bracciano, suddenly died. The close timing of the two deaths, the coincidence of the locations – another Medici villa, the one at Cerreto Guidi – and the fact that Troilo Orsini, who Isabella loved, was murdered by one of Francesco I's men the following year, fed the suspicion that this princess was also killed by her jealous husband with the support of her brother, the grand duke.

Beautiful, lively, witty, wise and held in high esteem by her father, Isabella was unquestionably the prima donna of the Florentine court, where she chose to spend much of her time, even after marriage. She loved pomp and was so mindful of her noble origins that she could be arrogant at times, unable to abide, for example, the insipid Camilla Martelli. She informed her cardinal brother in Rome of their father's second marriage, or rather the 'unpleasantness of the new thing', although 'imagining that [he] already knew all about it'. Making clear that 'this is something that one must swallow down, since there is no remedy for it', she urged the cardinal to defend their father's choice in public if the marriage was subject to ridicule, as had already been the case elsewhere, ending the letter with a prayer for extreme prudence: 'I beg you to burn this, since it would be my ruin if it were seen'. Her attitude towards the adulterous love of her brother Francesco for Bianca Cappello was different, perhaps due to the vague and shared emancipation of this Medici and the Venetian from the submissive roles forced upon women by society at the time. In September 1572, after learning that Bianca's father intended to bring his daughter back to Venice, Isabella wrote to her: 'Now think about what will happen if you put yourself in his hands, and how you will be treated! I remind you ... that here you are in your own house, as mistress, and there you shall be subject to your father ... and your unloving brother, and your sister-in-law!'

There is a fine painting on view at the Galleria Palatina that was once attributed to Bronzino but was actually painted by Alessandro Allori, or his workshop, that was traditionally believed to depict Laudomia, daughter of Lorenzo il Popolano. At the end of the twentieth century, however, scholars put forward the possibility that it is instead a portrait of Isabella de' Medici; what is certain is that the clothing indicates great wealth and a marked penchant for elegance. The sitter's hair is gathered in a net of cultured, and hence costly, pearls, embellished with precious stones set in gold. The black velvet dress with cut puffed sleeves is also decorated with white pearls. The striking jewellery includes a curious long belt that Isabella holds in her hand, like a leash for the soft marten draped on her arm, the nose of which has been transformed into a jewel.

◀ Alessandro Allori (?), *Isabella di Cosimo I (?)*, 1555-1560, oil on panel. Galleria Palatina.

THE STUDIOLO AND THE TRIBUNA: THE GRAND DUKE OF THE UFFIZI

FRANCESCO I (1541–1587)

Scipione Pulzone, known as Il Gaetano, did not exactly paint a portrait of Francesco I de' Medici but rather a painting of his portrait. The curtain reveals the clever trick: draped over the upper edge of the painting, set in a dimly lit space (the real background of the painting), it has been pushed aside to show the image of the second grand duke, wearing the cloak of the order of the Knights of St Stephen. Francesco rests his left hand, probably ruined by an unfortunate restoration, on the arm of the carved chair, while his right hand, the painter's masterful rendering of which can still be appreciated, is holding the collar of the Golden Fleece, the highest decoration of Habsburg, Spain. Membership in this elite, highly prestigious chivalric order indicated pro-Spanish politics. Emperor Charles V granted it in 1546 to Cosimo I; his son Philip II wanted to pass it on to Francesco (in 1585) and his reckless brother Pietro (in 1589), who served in the military in Spain, but not Ferdinando, who had preferred to extend the Medici alliances to disagreeable France. Ferdinand I commissioned Scipione Pulzone to paint the portrait after his brother's death, to replace a previous one that is also in the Serie Aulica. As we shall see below, the third grand duke also commissioned the artist to paint his own portrait and that of his wife Christina of Lorraine, all of which are distinguished by the curtain device.

Francesco had been handed the reins of government by his father in 1564. The next year, he married a young woman of extremely noble birth, Archduchess Joanna of Austria (1548–1578), the youngest daughter of the deceased Emperor Ferdinand I and sister of Maximilian II, who succeeded their father as Holy Roman Emperor. Cosimo I had procured a marriage for his eldest son full of prestige and political advantages, but not happiness, since before marrying Francesco had embarked on a love affair with Bianca Cappello (1548–1587), a charming Venetian who had escaped to Florence when she was seventeen with her beloved, the Florentine merchant Pietro Bonaventuri, who she married against her father's wishes. The only children of Joanna of Austria who survived to adulthood were Eleonora (duchess of Mantua) and Maria (queen of France). Between 1567 and 1575, the grand duchess had given birth to six daughters. In 1576, little Antonio was born, the son of Francesco and Bianca Cappello, although it was suspected that the mother had faked her pregnancy and the birth, passing off the son of another woman as her own. The following year, Filippo (1577–1582) was born, the only male child of Joanna and Francesco, but he died before he turned five, and in April 1578, again pregnant, Joanna herself died, leaving Francesco and Bianca both free of marital ties – Bonaventuri had been murdered in 1572 – and able to marry. Their wedding was held on 5 June, but at first keep secret, and indeed Cardinal Ferdinando continued to do his best to propose new matches for his brother Francesco, with the hope of political advantages for the family and possibly getting rid of the Venetian, who the cardinal detested.

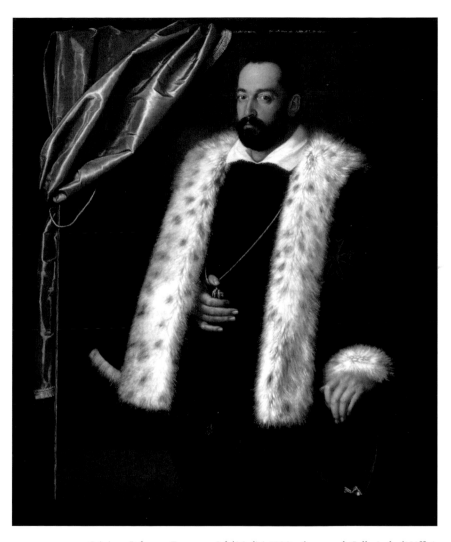

Scipione Pulzone, *Francesco I de' Medici*, 1590, oil on panel. Gallerie degli Uffizi.

Once the news spread of the sensational wedding, the Venetian Senate hastened to declare the father and brother of the new grand duchess knights and, forgetting that she had been until recently an outcast, granted her the title of 'Daughter of St Mark', a recognition that must have meant a great deal to Bianca, judging from the resentment expressed in a letter dated 5 June 1582 to the bishop of Pistoia Ottavio Abbiosi, upon the news that a female relative of the doge Niccolò da Ponte would also receive the title: 'We do not begrudge anyone the honour. It is to the merit of that lady in every respect she is eligible for every demonstration favoured by the

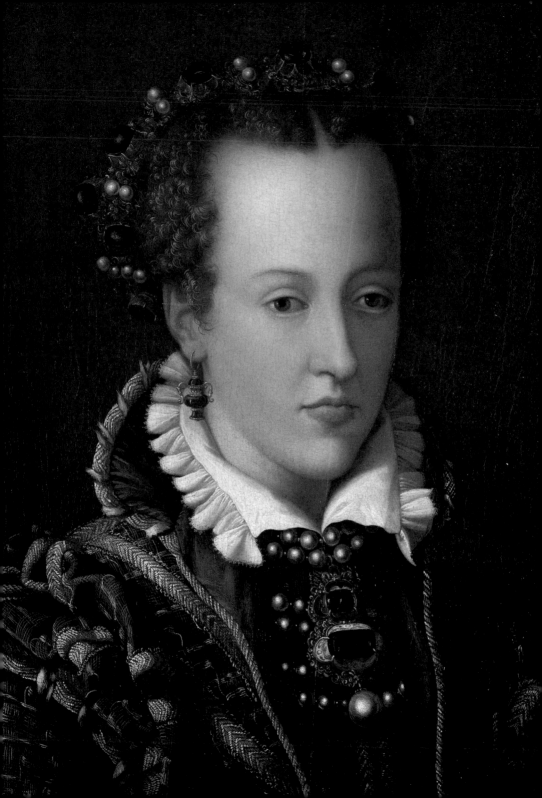

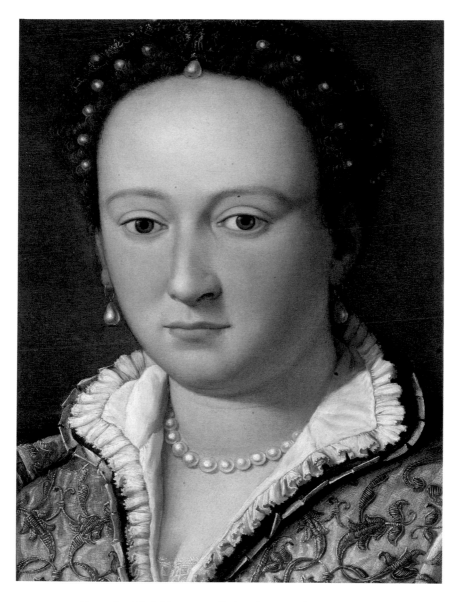

Alessandro Allori, *Bianca Cappello* (recto), 1578, oil on copper. Gallerie degli Uffizi.

◀ Alessandro Allori, *Joanna of Austria*, c. 1570, oil on panel. Palazzo Pitti, Tesoro dei Granduchi.

Republic. But . . . for the old custom of the Country to not give this rank and title except to Women who rule over Kingdoms or married to Princes equal in power and state to Kings, and to grant it now to someone married to a private cavalier shall be nothing more than lowering it too much.' Despite his melancholy nature, Francesco's union with Bianca was happy until their deaths from malarial fever in 1587, the one right after the other (19 October, Francesco; 20 October, Bianca). As with every premature death in the House of Medici, there was suspicion of poisoning and plots: Cardinal Ferdinando ordered an autopsy, even though, given the circumstances, the one to benefit most for the double death was himself, becoming the new grand duke. Having always been hostile to his Venetian sister-in-law, Ferdinando did not permit her to have a state funeral like her husband and did not even allow her to be buried in the Medici tombs in the church of San Lorenzo.

In his half-length portrait of Joanna of Austria, Alessandro Allori, talented student of Bronzino, demonstrated his taste for detail in his description of the materials, like the open-weave fabrics, modern decorative weaving that lends movement to the fabric where it is struck by light, an effect rendered by the painter with painstaking precision. It is not unusual to find traces in documents connected to the Guardaroba Medicea of clothing and jewellery lent to artists so that they could reproduce them with care in portraits. Among the precious jewellery displayed by the grand duchess, the gold and enamel 'garland' decorated with emeralds and pearls fits the description of the one made by the Dutch goldsmith Hans Domes and given to the duchess as a gift by her father-in-law Cosimo I. Other striking pieces are the large ruby and emerald pendant and the gold and enamel vessel-shaped earrings, which were in all likelihood filled with a 'sweet-smelling paste' made of flowers and civet.

Among the many Medici portraits made by Allori, we find a copper sheet painted in oil on both sides. On the front, there is a portrait of Bianca Cappello, her hair studded with pearls and wearing pearl earrings and a pearl necklace, all cultured and glowing, in clear reference to the name of Francesco I's second wife. The large pendant above her forehead is quite unusual, a three-dimensional piece with the figure of Venus embraced by her little son Eros. The presence of the goddess of beauty and the god of love is connected to the back of the painting, where we find a scene known today as *Allegory of Human Life*, rendered in very bright hues given the particularity of the support. The painting is after a drawing made by Michelangelo for Tommaso de' Cavalieri, to whom the artist was deeply attached, and called *The Dream* by Vasari in his *Life of Marcantonio and Other Engravers of Prints*. While the painted version differs a little from the drawing, both show an angel playing a trumpet while plummeting towards a young man leaning on a globe; in the semicircle of clouds behind him are scenes linked to the vices. The theatrical masks jumbled together in the young man's bench might allude to the different faces taken on by

Alessandro Allori and workshop, *Allegory of Human Life* (verso), 1578, oil on copper. Gallerie degli Uffizi. ▶

life's events, sometimes difficult to recognise for what they are and that the human mind tangled up with vice can dominate through the call of virtue. While the full meaning of Michelangelo's allegory remains unclear, the decision to paint it on the back of the portrait of Bianca Cappello might be an allusion to the purifying strength of the sincere love between her and the grand duke Francesco.

The interest in alchemy shared by Francesco de' Medici and his father Cosimo is behind the decoration of the renowned Studiolo in Palazzo Vecchio. Typical of Renaissance residences, studioli were small 'secret' rooms, in the Latin meaning of the term, which is to say private, where more valuable objects were kept along with literary rarities and personal documents. Towards the end of 1570, Francesco entrusted the conception of the decorative programme for the small room to the philologist Vincenzo Borghini, who devised a sophisticated iconographic 'mosaic' of paintings and bronze statues made for the most part by the best students at the newly-minted Drawing Academy founded in 1563 by Cosimo I to offer artists a designated place of learning, until then relegated to workshop practice, and which had become famous for organising Michelangelo's funeral service. The mysterious decoration of the Studiolo winds among mythological scenes, supernatural figures fishing for pearls and coral, artisans focused on casting bronzes, making jewellery, distilling with alembics and much more, all traceable to the alchemical and real world of the prince, who could often be found busy in the foundry or the pharmacy. There is little trace of the original contents of the Studiolo's cabinets in the archives, proof of the highly private nature of this space. We can imagine that they held the statuettes that Francesco later moved to the Tribuna in the Uffizi, restored with materials taken from ancient Roman marbles requested from Cardinal Ferdinand, as we glean from a few letters from the grand duke to this brother in the spring of 1581: 'Pigli Vostra Signoria Illustrissima la sua comodità nel mandarmi le pietre che le ho domandate … l'aspetto con desiderio per dare principio a rassettar mille cosette piccole che mi trovo' (At your convenience, Your Most Illustrious Lord, prepare to send me the stones I asked you for … I eagerly await them to repair a thousand little things I own). The Tribuna of the Uffizi, an octagonal room of astonishing beauty, designed by Bernardo Buontalenti for Francesco I in 1584, is topped by a dome that shifts in hue from vermilion to gold and is set with 5,700 oyster shells (pinctada margaritifera) that reflect the natural light. With the 'paintings, statues and other valuable things' already installed by the prince on the top floor in 1581, the Tribuna can be considered the foundation stone of the museum function adopted by the buildings that now host the Uffizi Gallery, universally recognised as one of the most important museums in the world. Having granted illustrious visitors access to the space, from then on all the Medici made sure to keep their most beautiful works of art in the Tribuna, including Michelangelo's Doni Tondo and Titian's Venus of Urbino, as well as some of the most important archaeological finds of the time, like the Medici Venus and the Wrestlers, both of which are still there today, or the renowned Chimera of Arezzo, now at the Museo Archeologico in Florence, a rare Etruscan bronze unearthed 'in

the time of Duke Cosimo I, which is today tamer of all chimeras', as reported by Vasari in his *Ragionamenti*.Over the years, the better part of the Medici portraits discussed in this volume were displayed in the Tribuna, thanks to their artistic quality, putting a face on the lords and ladies of this sanctuary of art.

'WHAT ONE DOES NOT DO IN ONE NIGHT ONE WILL NOT BE ABLE TO DO EVEN IN TWO'
ELEONORA DE' MEDICI (1567–1611) AND VINCENZO I GONZAGA (1562–1612)

The wedding ceremony painted by Jacopo da Empoli (born Jacopo Chimenti) is of a piece with other paintings similarly made for temporary display, but the story that led to the marriage of Eleonora de' Medici and her cousin Vincenzo Gonzaga is unique. Backed by the count of Tyrol, Ferdinand II, brother of the mother of the bride as well as that of the groom, the wedding was held on 29 April 1584, but the painting was made later and the model for Eleonora's dress was the one worn by her sister Maria for her own royal wedding in 1600. The features of the bride and groom are also not very accurate, but the purpose of this kind of painting, made to be displayed during processions or festivities, was to celebrate the union's prestige.

Vincenzo di Guglielmo Gonzaga, duke of Mantua and Montferrat had first married Margherita Farnese, princess of the duchy of Parma and Piacenza, who was then rejected and persuaded to enter a convent, because it had not been possible to consummate the marriage. According to the doctors consulted in Mantua, the problem was that the young woman had a congenital deformation, but the Farnese family argued that Vincenzo had been unable to carry out his conjugal duty. The choice of a second wife thus fell to Eleonora di Francesco I de' Medici, who had actually already been offered in marriage to the Gonzaga prince a few years before. The situation, however, was completely changed: worries about Vincenzo's presumed impotence weighed upon negotiations for the return of the dowry in case of death with no heirs and, what's more, Eleonora was also being pursued by Charles Emmanuel I of Savoy, whose expansionist interests in the Montferrat region administered by the Gonzaga would have been unstoppable if supported by the Medici. Francesco I decided to hold a public demonstration of Vincenzo's virility, for which a beautiful young virgin was found who was willing, for a fee, to allow eyewitness to verify the prince's prowess. Gonzaga repeatedly said that he was certain he would succeed and impatient to prove it. However, on 23 January 1584, the grand duke wrote to his brother Ferdinando that, on the agreed upon night, 'the Prince sent a message … that he did not want to do it in just one night and wished for three or four and, receiving the reply that what one does not do in one night one will not be able to do in two, the Prince gave up that very night

and left for Mantua in the morning without wanting to try again.' In the end, however, the demonstration was eventually carried out in the presence of Belisario Vinta (a close associate of the grand duke of Tuscany), who 'saw' and 'touched with his hand'. Such that the grand-ducal secretary Antonio Serguidi was able to report to his counterpart in the employ of Cardinal de' Medici, on 19 March 1584, that 'the Prince of Mantua has happily succeeded ... such that one is fully satisfied in this matter'.

When Guglielmo Gonzaga died in 1587, Vincenzo took over the government of Mantua and Montferrat, and Eleonora became duchess consort. Their new rank required consonant participation in the festivities for the wedding of her uncle Ferdinand I de' Medici to Christina of Lorraine in 1589, the accounting records for which reveal the expenses incurred for the guests of the groom, who had to pay for transport and one month's food and lodging for the retinue of the dukes of Mantua, an entourage of 300 individuals.

Jacopo Chimenti called l'Empoli, *Marriage of Eleonora de' Medici with Vincenzo Gonzaga*, c. 1600, oil on canvas. Gallerie degli Uffizi. ▶

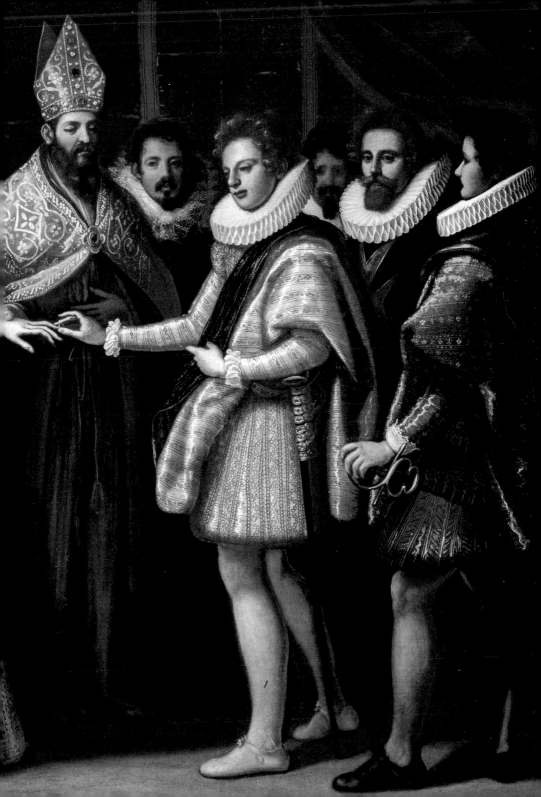

SINGLE AT THE RIGHT TIME

MARIE, QUEEN OF FRANCE (1575–1642)

For the wedding portrait of Marie de Médicis, of which this painting in the Serie Aulica is a faithful and autograph copy, Frans Pourbus the Younger was offered 100 scudi to paint the whole thing himself or fifty to do just the head and hands, passing the rest to a student. In this representation of the sovereign, who was crowned in the abbey of Saint-Denis on 12 May 1610 (ten years after her wedding) on the wishes of her husband, the Bourbon king Henry IV (who was murdered two days later), one is struck by the lavish clothing: a true political manifesto rendered with the masterful attention to detail typical of Flemish artists. The intense blue of her dress and ermine-lined mantle evokes the field of the coat of arms of the Capetian monarchy, enlivened by a multitude of gold-embroidered fleurs-de-lis. The corset is also in the shape of a fleur-de-lis, in this case upside down, and embellished, like the cut sleeves, with pearls and precious stones that form a frame around a pectoral cross of astonishing size. Fine needle lace and large lustrous pearls adorn her wrists and square neckline. When her husband died, Marie became regent to her son Louis XIII, who was still a child, a delicate role that the various copies of this official portrait helped legitimise.

Marie, the youngest daughter of Francesco I de' Medici and orphaned at a young age, lived at the court of her uncle Ferdinand I with all the honours that were her due. Although she received a few earlier proposals, she married relatively late, which was unusual for the time and the Medici family. When Henry IV expressed his wish to marry a Medici, hoping in part for the cancellation of his debt with the Florentine bank which had granted him sizeable loans, Ferdinand I's daughters were still children and Henry, already advanced in years, was anxious for a legitimate heir. Given the young age of her cousins and time being of the essence, Marie was the only Medici princess available for this prestigious marriage. Once the king's previous marriage to Margaret of France (daughter of the first Medici queen, Catherine) was annulled, Margaret having been well-compensated for her consent, Marie and Henry were married by proxy. The bride brought with her an enormous dowry, which lessened but did not fully wipe out the debt of the king of France. For the magnificent wedding banquet, held in the Salone dei Cinquecento on 5 October 1600, Jacopo Ligozzi was commissioned to build a giant credenza in the shape of a lily, an astonishing display case measuring seventeen metres high and backlit with lanterns, hosting about 2,000 sparkling gold and silver treasures. Guests were dazzled by the elaborate dishes, sugar sculptures designed by the sculptor Giambologna and the ingeniously folded linen napkins arranged on the table, as reported by Michelangelo Buonarroti the Younger in his *Descrizione delle felicissime nozze della cristianissima maestà di madama Maria Medici regina di Francia e di Navarra*: 'a white composition, that seemed almost all in marble. Two tall oaks that formed

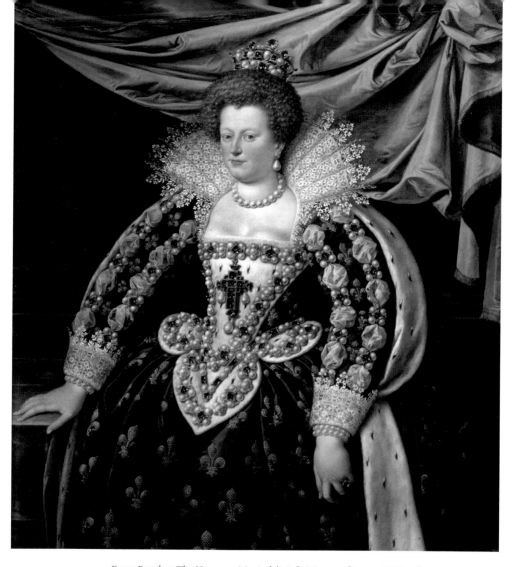

Frans Pourbus The Younger, *Marie de' Medici Queen of France*, 1613, oil on canvas.
Gallerie degli Uffizi.

a forest for many animals, who seemed to be pursued by men and dogs in the middle of hunt. ... An elephant beneath one of them, a rhinoceros beneath the other, life-sized, complete with folds ... with men holding up saddle cloths embellished with Moorish decorations.'

Much has been written about this important queen of France and her stormy relations with her son Louis XIII, often influenced by the ambitions of members of their respective courts, like the Florentine Concini and the immensely powerful Cardinal Richelieu. She died alone and far from Paris.

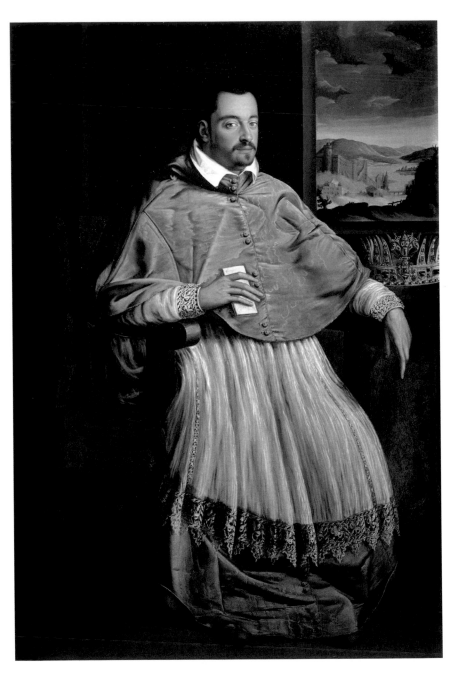

Florentine painter from the workshop of Alessandro Allori, *Ferdinando I de' Medici in cardinal's robes*, oil on canvas, c. 1588. Gallerie degli Uffizi.

RENOUNCING THE CARDINALSHIP TO RULE FLORENCE
FERDINAND I (1549–1609)

Ferdinand di Cosimo I de' Medici became cardinal when he was just thirteen. Although he had been at first little inclined towards study (it seems his difficulty expressing himself in Latin during consistories was mocked by the cardinals hostile to him), he held many public posts in Rome, distinguishing himself for his organisational skills and political acumen, while also devoting himself to intense art patronage. When Francesco I died, and the dynastic rights that the young Antonio de' Medici could have laid claim to, having been legitimised after his father's marriage to his mother Bianca Cappello, were swept aside, Ferdinand became the new grand duke by acclamation, but his brother Pietro took legal action, with the support of a few jurists from Salamanca, in order to secure for himself government of the territory of Siena, enfeoffed to Cosimo I in 1557 by the Spanish Habsburgs. Decisive for the longed-for reconfirmation of the investiture of the Sienese state (1605) were the death of 'don Pedro' in 1604 and the promise to submit to the Spanish sovereign for the choice of a bride for his eldest son, the future Cosimo II, who did end up marrying a Habsburg archduchess, as advised by Margaret of Austria, the energetic wife of Philip III of Spain and sister of Grand Duchess Giovanna. Although he took up government of the grand duchy of Tuscany, Ferdinand had no intention of stripping himself of his cardinalship, holding it opportune to instead retain its advantages. For example, on 22 October 1587, he wrote to Cardinal Marcantonio Colonna in Rome: 'I plan to keep the hat as long as I can, and I know that I shall thus be able to hold onto the protection of Spain'. However, in the end, Ferdinand had to resolve to abandon the cap for the usual urgency of ensuring the continuation of the family line, and chose to marry Christina of Lorraine (1565–1636), granddaughter of Catherine de' Medici, partly to put an end to the international suit that had been brought by the queen of France to claim the assets of her (presumed) brother Alessandro, first duke of Florence, invariably inherited along with the title by the successors of Cosimo I. Christina was the daughter of Charles III, duke of Lorraine and Catherine's third child, Claude of Valois, who died before her daughter turned ten. And so, her Italian grandmother kept her close in Paris, saw to her education and handled negotiations for her Tuscan marriage.

Ferdinand ruled with a firm hand: he fought against banditry, improving even the countryside, and his policy boosted not only Florence and Siena but also Pisa and Livorno, where he is honoured with a marble monument with the four famous bronze Moors chained at the base, now one of the city's emblems. Among the many works commissioned by Ferdinand I, two major achievements still mark the urban fabric of Florence today. The first is the equestrian statute of Cosimo I (1587–1595) in Piazza della Signoria, for which the Flemish sculptor Jean de Boulogne, known as Giambologna, needed to set up a special workshop for casting

the work, the dimensions of which were larger than anything ever before seen in Tuscany, in a modern reinterpretation of the *Marcus Aurelius* in Rome. The second is the equally impressive equestrian monument of Ferdinand I (1601–1608), commissioned from Giambologna and later completed and installed in the Piazza della Santissima Annunziata by his student Pietro Tacca. The underbelly of the horse bears the inscription 'De' metalli rapiti al fiero Trace' in commemoration of the cannons seized from the Turks by the Knights of St Stephen and used to cast the statue.

The portrait by an unknown artist based on a painting by Scipione Pulzone of Ferdinand I dressed as a cardinal and with the grand-ducal crown resting on a table, can be considered an illustration of that curious early phase of his rule. Ferdinand is wearing a red marbled silk mozzetta over a soft, densely pleated rochet, with a finely worked lace border embellished with a Florentine iris motif. In 1590, Ferdinand called Scipione Pulzone to Florence. He put him up in Palazzo Pitti with two other people and provided him with the finest materials so that, as we read in Giovanni Baglione's *Vite de' pittori scultori et architetti*, 'he could portray him in frontal view with the Grand Duchess. [Pulzone] succeeded and expressed the one and the other in a life-like manner, such that they lacked nothing but speech'. The device of the curtain resting on the frame, found in the portraits of both Ferdinand and Christina, reveals that we are again looking at two 'paintings of paintings'.

Ferdinand rests his wrist on a magnificent parade helmet, which is incised with a scene from the Battle of the Centaurs; the hand, like the face, is painted with extraordinary naturalism. The strength of the composition lies in part in the chromatic balance that reinforces the rendering of the materials. The gleaming hardness of the gold metal stands out against the soft, bright-pink velvet and picks up the shine of the violet silk curtain, the gold border of which harmonically corresponds with the blue and gold stripes of the breeches. This carefully constructed play of hues enlivens the already extremely natural features and pose. The grand duke is wearing the ceremonial robes of a grand master of the nautical order of the Knights of the martyred pope St Stephen, founded by his father Cosimo in 1562 in Pisa. In that city, Cosimo commissioned Vasari to build the splendid Palazzo della Carovana (also known as Palazzo dei Cavalieri), the headquarters of the order until the nineteenth century, and now part of the prestigious Italian university, the Scuola Normale Superiore di Pisa. The Order of St Stephen met the need to strengthen the effectiveness of the Medici navy through solid organisation and to tie the grand duke – who served as grand master – to the younger members of the influential families that took active part in the congregation.

In the portrait of Christina of Lorraine, made as a pendant by Il Gaetano, as Scipione is also known, the grand duchess is wearing an elegant dress in a delicate hue somewhere between powder blue and iridescent pearl grey. The bodice and double sleeves are secured with pointed elements embellished with pearls and pink enamel flowers that echo the pale, shot-silk hue of the curtain. Her shoulder is

decorated with an elegant brooch with an oblong pearl pendant and embellished with small figures and fantastical heads surrounding a large table-cut diamond in a coloured enamel setting. She is also wearing a matching necklace and belt made of large precious stones and her hair is fastened with a drop-pearl and ruby pin. This painting preserves the best reproduction of the crown, now lost, made by the court goldsmith Jacques Bylivelt for Francesco I and used until 1691 when Cosi-

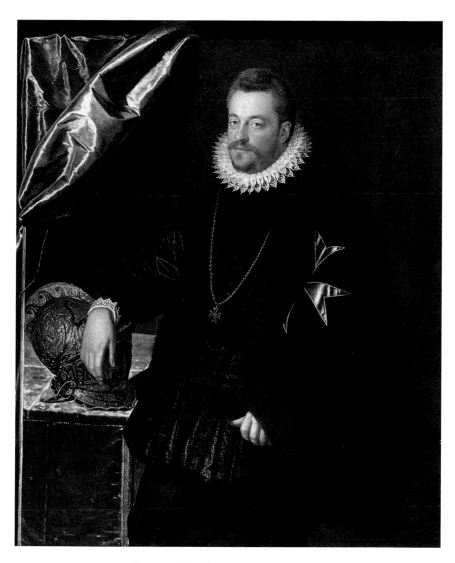

Scipione Pulzone, *Ferdinand I de' Medici*, 1590, oil on canvas, Gallerie degli Uffizi.

mo III was granted the 'royal treatment', which included the right to add elements to the grand-ducal crown. The crown made by Bylivelt had replaced an earlier one made in a hurry for Cosimo I during the short period between the concession of the grand ducal title (27 August 1569) and the coronation ceremony (5 March 1570): based on a drawing at the bottom of the papal bull elevating Cosimo to grand duke, it was a new type of crown, just as 'grand duke' was a new title.

Christina gradually carved out a role for herself as chief advisor to her husband, who also admitted her to the Council of State, and then to her son Cosimo II, who then died prematurely, leaving his mother and his wife, Maria Maddalena of Austria, joint guardianship of his eldest son, who was still a child. Thus began the regency of the 'Most Serene Madames', 'madame' being the title of respect given to foreign ladies, while the Latin expression *mea domina* was derived from the custom of referring to Florentine women as 'madonna', sometimes contracted into 'monna'.

Bull of Pope Pius V granting the title of grand duke to Cosimo I de' Medici and his successors, August 27, 1569, illuminated parchment. Florence, Archivio di Stato di Firenze, Trattati internazionali (International Treatises).

Scipione Pulzone, *Christina of Lorraine*, 1590, oil on canvas. Gallerie degli Uffizi. ▶

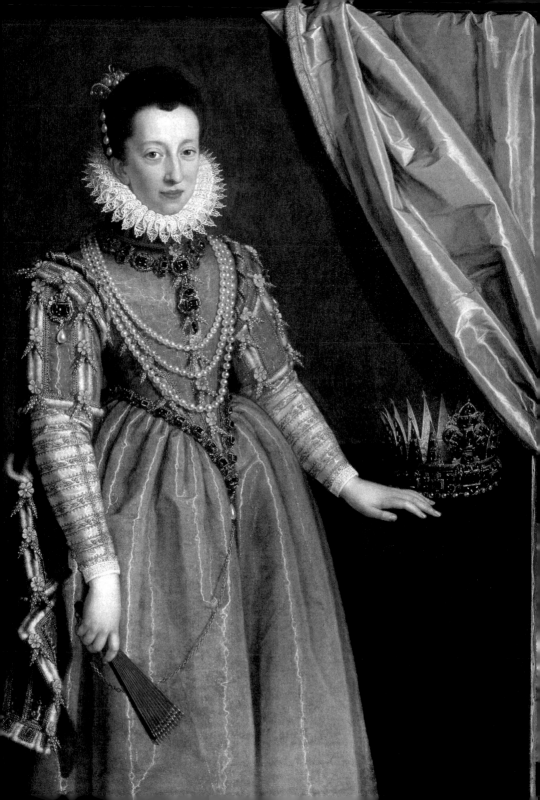

THE REGENCY OF MOTHER-IN-LAW AND SISTER-IN-LAW
From Cosimo II (1590–1621) to Ferdinand II (1610–1670)

The triple portrait of Cosimo II with his wife and eldest son Ferdinand, by the Flemish painter Justus Sustermans (or Suttermans), who served as official court portraitist for sixty years, is an impossible painting. X-rays have revealed that the left arm of Cosimo II (in the middle), the only figure originally in

the painting, was holding a large helmet, which was then covered up to add the other two figures, resulting in a composition as inconsistent in the treatment of space as in the reciprocal relationships between the figures. Cosimo, who died of tuberculosis in 1621 when he was just over thirty, is flanked by his wife, Maria Maddalena of Austria, and their son Ferdinand II, portrayed as an adult, even though he lost his father when he was only eleven. While Cosimo is wearing rich armour magnificently decorated with allegorical figures, including, on the chest, *Justice* with a sword and scales, Ferdinand II displays the badge of the order founded by the Medici, the Knights of St Stephen, rights to the grand mastership of which belonged to the sitting grand duke of Tuscany. The painting is therefore a kind of pastiche that ignores temporal reality, instead reinforcing the legitimacy of Maria Maddalena's regency while her son was a minor, a role that she shared with her mother-in-law, Christina of Lorraine.

Maria Maddalena, already archduchess of Austria, is wearing a black overgown embellished with pearls over a white petticoat decorated with dense gold embroidery. Especially striking are the lace collar that starts below the neck and frames her head, and the yellowish diamond she wears in her hair, known as 'The Florentine' and often included in her portraits. Various legends swirled around this 138-carat, or 27.6-gram, gem, even before its purchase by Ferdinand I in Rome in 1601 for 35,000 scudi. Wishing to give it to his wife, Cosimo II entrusted it to the Venetian goldsmith Pompeo Studendoli, who filled it with facets and set it in a pendant mount. When the Medici dynasty died out, the diamond became part of the royal treasury of Vienna, but all trace of it was lost in the early twentieth century. There is a cross-shaped reliquary in the collection

of the Museo dell'Opera del Duomo, Florence, a gift from Grand Duchess Maria Maddalena, with a topaz on top that was cut, a few years later, in imitation of the Florentine in the same grand-ducal workshop where the diamond had been cut and set.

Cosimo II had a sparkling, intelligently cultivated personality; one of his teachers was Galileo Galilei (who

◄ Justus Sustermans, *Cosimo II de' Medici between his wife Maria Maddalena of Austria and his son Ferdinando II*, c. 1640, oil on canvas. Gallerie degli Uffizi.

Domenico and Valore Casini, *Maria Maddalena of Austria* (detail), before 1619, oil on canvas. Gallerie degli Uffizi.

Sustermans also portrayed in a famous portrait, also in the Uffizi collection), to whom he remained bound by profound esteem his entire life. Galileo dedicated two of his works to the prince, *Le operazioni del compasso geometrico et militare* (1606) and *Sidereus nuncius* (1610), in which he announced his discovery of Jupiter's moons, which he called 'Medici planets'. And, for his part, Cosimo II, by this point grand duke, offered the scientist the post of First Mathematician and Philosopher to the Grand Duke, for which Galileo returned to Tuscany, leaving the University of Padua where he had taught for eighteen years. Maria Maddalena and Cosimo had eight children, many of which fruitfully cultivated myriad humanistic and scientific interests, which are in a certain sense documented in the two portraits made by Sustermans two days apart in order to track the development of the smallpox that struck Ferdinand II in 1626. The latter, at ease amidst barometers and thermometers, fostered Florentine cultural life as much as his growing governmental responsibilities allowed. In 1657, he supported the founding of the Accademia del Cimento, set up by his highly cultured brother Leopoldo and the first experimental academy in Europe, as announced by its motto: 'try and try again'. Ferdinand found himself having to facing the plague of 1630, which hit Tuscany hard, and the Thirty Years War, during which the traditional impartiality of the Medici state was shaken by the rivalry between the two regents, with Maria Maddalena of Austria obviously siding with the imperial coalition and the French Christina of Lorraine supporting the anti-Habsburg alliance. Ferdinand II continued the reorganisation of the government and court posts begun by his father Cosimo II, gradually transforming them into the prerogative of the aristocratic and ecclesiastic classes. Thus abandoning one of the founding strengths of the Medici dynasty, which paired economic possibilities with the wisdom to surround itself with gifted individuals to entrust with administrative, judicial and financial privileges based on merit rather than merely social provenance.

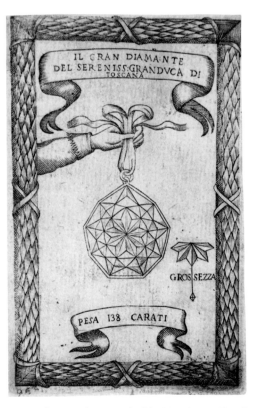

The Grand Diamond of the Most Serene Grand Duke of Tuscany, engraving, 1615–1619. Florence, Biblioteca Marucelliana.

Justus Sustermans, *Ferdinand II de' Medici on the seventh day of smallpox*, 1626, oil on canvas. Galleria Palatina; Justus Sustermans, *Ferdinand II de' Medici on the ninth day of smallpox*, 1626, oil on canvas. Galleria Palatina.

Under the highly religious regents, the members of the clergy grew increasingly meddlesome, becoming under Cosimo III a sizeable proportion of the city population. The two 'madames' also procured a match for Ferdinand II that marked the beginning of a series of unhappy unions in the House of Medici.

COLLECTING BRILLIANCE

LEOPOLDO (1617–1675)

Although the artist Giovanni Battista Gaulli, known as Il Baciccio, made no attempt to refine the inharmonious physiognomy of Leopoldo de' Medici, by this point old, the intensity of the sitter's expression makes this portrait a superb painting: the cardinal seems to be conversing with the viewer, and is so focused on listening that his 'Habsburg chin', inherited from his mother's side, has become mixed up with the way that we sometimes unwittingly leave our mouths partially open when our attention is deeply engaged. His eyes reveal his mental agility and quickness of thought, a reflection of Leopoldo's brilliant personality, capable of even overcoming the suffering of ill health, which we can perceive in the dull complexion of his emaciated face and the composed decorum of his pose, wearing the mozzetta and holding the cap in his hand, in cele-

Giovanni Battista Gaulli called il Baciccio, *Leopoldo de' Medici*, 1668-1670, oil on canvas. Gallerie degli Uffizi.

bration of his recent elevation to cardinal. The painting, which might have been commissioned to satisfy a request from Margherita de' Medici, duchess of Parma (who had written to her brother on 26 November 1669: 'remember that none of us has yet seen you dressed as cardinal'), was probably made by Il Baciccio during Leopoldo's second Roman sojourn, when he was occupied with the long conclave that ended with the election of the Altieri pope Clement X.

It is difficult to explain the feverish collecting and scholarly activity of Prince Leopoldo de' Medici without describing thousands of works of art, books, paintings, statues, drawings, and then coins, medals, gems, as well as scientific instruments, weapons, musical scores, ivories, crystals and much more. An idea of the degree to which he stands out even amidst the traditionally intense collecting activity of his family can be gleaned from the Carteggio d'artisti, a collection of documents preserved at the Archivio di Stato, Florence, dating from the fifteenth to the seventeenth century and gathered during the second half of the latter with the aim of reconstructing the provenance of part of the Uffizi collections. Among the twenty-one volumes in this collection, eighteen almost exclusively concern letters relative to objects considered by Leopoldo for his personal collections. The most astonishing thing is his expertise in a vast range of subjects: himself a painter, founder of the scientific society the Accademia del Cimento, active supporter of the study of the Italian language at the Accademia della Crusca, this member of the Medici family spent his life studying and collecting. His collections contain all manner of objects from the famous lens used by Galileo Galilei to observe the movement of Jupiter's moons (the above-mentioned 'Medici planets'), which also helped prove the heliocentric theory, to Raphael's *Portrait of Tommaso Inghirami*. Leopoldo collected Greek, Roman, Etruscan and Egyptian antiquities with the same intelligent curiosity with which he acquired objects from far-off lands like Mexico and China. Thanks to his correspondence with a vast network of associates, scholars and connoisseurs in cities across Italy and Europe, Leopoldo was able, starting in the 1660s, to also procure numerous self-portraits of artists, probably the most admirable collection of its kind, today at the Uffizi. In more than one case, the cardinal himself commissioned the self-portraits, including the ones of Guercino and Pietro da Cortona. The latter sent his painting with a note explaining that in his self-portrait he had not wished to gloss over the fact that he was suffering from a worsening illness, and he was compensated with a silver chest full of medicine.

THE BRIDE WITH TITIAN'S *VENUS* IN HER DOWRY
VITTORIA DELLA ROVERE (1622–1694)

The over-abundant painting by Johann Zoffany in the United Kingdom's Royal Collection known as *The Tribuna of the Uffizi* (1776) offers a view of just one side of the renowned octagonal room packed with paintings and statues all the way up to the mother-of-pearl spiral decoration of the drum of the dome. Even the floor is covered with works, surrounded by scholars and connoisseurs. In the middle of the composition, in the foreground, the British resident and diplomat Sir Horace Mann is studying a large painting: the famous *Venus of Urbino*, one of Titian's masterpieces. This extraordinary painting had come to Florence in 1631 along with Piero della Francesco's diptych with the portraits of Federico da Mon-

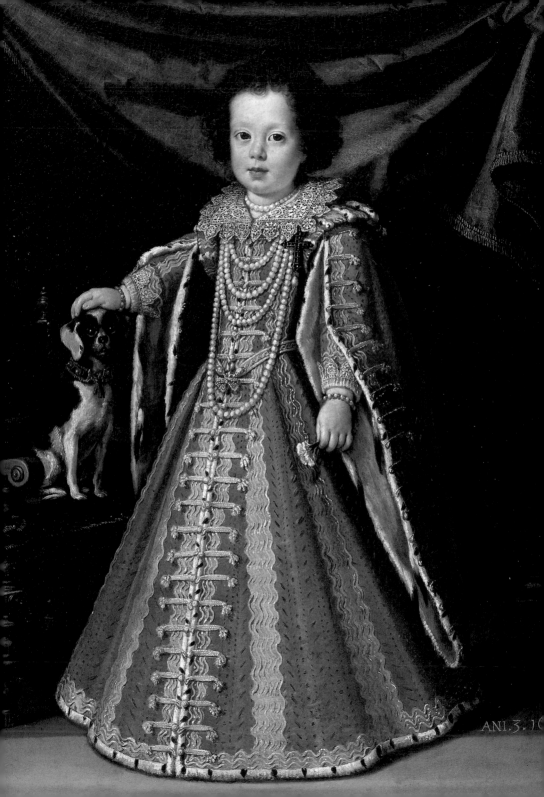

tefeltro and Battista Sforza and many others, by way of the inheritance of Vittoria Feltria della Rovere, betrothed to her cousin Ferdinand II when she was just twenty months old.

Vittoria was born to Claudia, the youngest daughter of Ferdinand I (1604–1648), and Federico Ubaldo della Rovere (1605–1623), whose death marked the end of the line. When her husband died, Claudia retired with her newborn daughter to the convent of the Crocetta in Florence, abandoning her three years later to move to Austria as the bride of Leopold V, count of Tyrol, while little Vittoria was sent to live with her grandmother Christina of Lorraine at Palazzo Pitti.

When her father died, his allodial property (not tied to a feud) flowed into Florence, Vittoria, being the sole heir, but the Medici's hope to also obtain the duchy of Urbino and strategically control the whole centre of the peninsula, from the Tyrrhenian Sea to the Adriatic, was met with firm opposition from the energetic Barberini pope Urban VIII. The widowed duchesses of Tuscany, regents to Ferdinand II, did not have the power to oppose the return of the Della Rovere family's ducal title, granted by the pope, to the Church, but their influence was decisive for the education of Vittoria, shaping the severe religiosity and love of splendour of the 'little bride', as she was called at court from a young age. And it is with the peculiarity of a child bride that this three-year-old girl is portrayed in the portrait attributed to Tiberio Titi, son of the more famous Santi di Tito.

The little girl is depicted standing in front of drapery, in the traditional pose for official portraits of adults, dressed in a long, Hungarian-style robe the width of which suggests that she was also wearing a hoop skirt of some kind, which would have been fashionable at the time but not suitable for children and so it might have only been worn for posing. Her fur-lined dress, richly embellished with silver trimming, and her long pearl necklace were certainly more suited to an adult woman. One concession to the concern owed children are the pearl and coral bracelets, since coral was believed to provide protection from illness and the evil eye. Vittoria and the little dog she is petting both look at the viewer, as if to stress the little girl's status as a 'bride', the dog being a symbol of marital fidelity. The grand duchess actually had many dogs, some of which came to Florence as valuable diplomatic gifts. In about 1648, she commissioned the painter Giovanna Garzoni to depict one of them lying on a table, *Lapdog with Biscotti and a Chinese Cup*, now at the Galleria Palatina.

The fine oil on copper painting of *Vittoria della Rovere as St Margaret* was instead by Justus Sustermans, the court portraitist for the last of the Medici line. Here, the grand duchess is depicted in the guise of the saint from Antioch, protector of women in labour, who was first closed up in a pitch-black cell and then swallowed by the devil in the form of a dragon, only to escape victorious from the monster's belly,

◄ Tiberio Titi (attributed to), *Vittoria della Rovere at the Age of Three*, 1624, oil on canvas. Gallerie degli Uffizi.

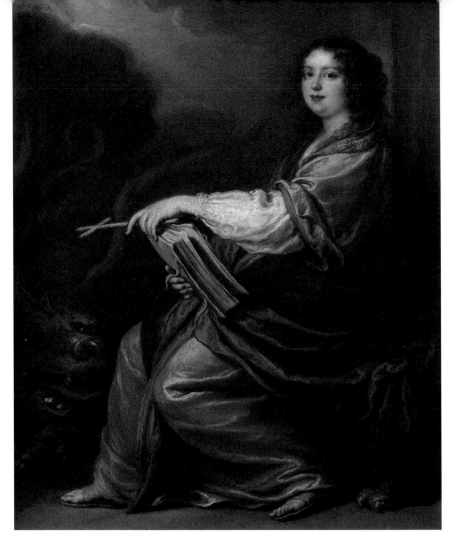

Justus Sustermans, *Vittoria della Rovere as Saint Margaret*, c. 1640, oil on copper. Galleria Palatina.

opening the way with her crucifix. The atmosphare of the painting is magnificent, conjuring an unreal world of sulphurous clouds that shatters the concrete environment of the prison, with a unified palette that encompasses everything from the background to the dragon and the precious fabrics of the saint's clothing and a pictorial rendering that gradually becomes more decisive, exalting the figure of Vittoria/Margaret in a crescendo of reality. The grand duchess's devotional passion, which she passed down to her son Cosimo III, sometimes descended into ostentatious piety in both. However, the propagandistic function of the official portrait might have been the real reason behind the considerable number of paintings that

Justus Sustermans, *Claudia di Ferdinando I de' Medici*, 1621, oil on canvas. Gallerie degli Uffizi.

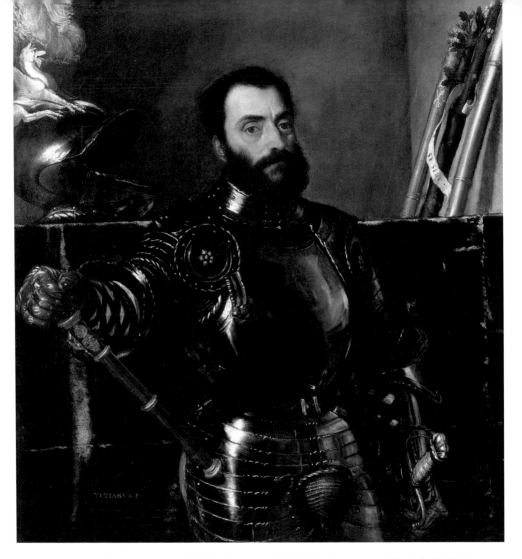

Tiziano Vecellio, *Francesco Maria I della Rovere*, c. 1536–1538, oil on canvas. Gallerie degli Uffizi.

portray Vittoria della Rovere in the guise of female saints, the Madonna teaching the Christ Child (Cosimo III) to read and even the Roman Vestal Virgin Tuccia. Her son Cosimo had himself portrayed as St Joseph after he decided to add this saint to the traditional protectors of Florence, Saints John the Baptist and Zenobius.

The portrait of Claudia de' Medici painted in Florence by Justus Sustermans is dated by most scholars to the year of her first wedding (1621). The painter has successfully defined her features, which are delicate in spite of her pronounced nose and almost icy stare, accentuated by the pale hue of her eyes, and lingered over the description of her clothing and jewellery. Her jewels include an enormous, enam-

elled gold brooch with diamonds and hanging pearls, a sixteenth-century chain worn diagonally across her chest in a more modern spirit and an affected hair ornament hung with pearls and small precious stones.

There are various other portraits of members of Vittoria's family in Florence's museums, including two masterpieces by Titian. For the portrait of Vittoria's great-great-grandfather Francesco Maria I della Rovere (1490–1538), the duke's valuable German armour was sent to Venice so that Titian could work directly from it but not the subject (a curious practice but not unusual for Titian), whereas he worked from a sketch for the subject's features, still managing to capture his appearance and psychology, as noted by Pietro Aretino in a letter to the poet Veronica Gambara dated 7 November 1537: 'his every wrinkle, hair and mark, and the colours used to paint him not only show the boldness of the flesh but reveal the virility of the soul'. Titian's quick brushwork captured every detail, tricking the eye by conjuring with paint now the warmth of the bright red velvet, now the silvery glimmer of light on metal, now the smooth softness of the complexion marked by time. Francesco Maria is holding a military commander's staff in one hand; other staffs can be seen on the shelf behind him, where there is also a helmet topped with a fantastical crest: one of them bears the papal insignia (his uncle Julius II had appointed him captain general of the Church), while another is a simple oak branch, flowering and with acorns, with a cartouche wrapped around it inscribed with the motto se sibi (By Himself Alone), to indicate that Francesco Maria's distinguished military career is to be attributed to his own glory and that of the house. The figure of a girl had been sketched on the canvas used by Titian for this painting, as revealed by X-rays made in view of the painting's restoration.

Not long before, Titian had painted the portrait of Eleonora Gonzaga (1493–1550), wife of Francesco Maria, which also won Aretino's praise, describing it thus in an ekphrastic sonnet: 'The harmony which rules in Leonora … her gentle spirit … Modesty … Honesty resides in her'. The duchess is shown sitting next to a window open onto a bright landscape with a busy sky that invites the eye. She is richly dressed in a black velvet dress covered with small gold bows. On the table, next to a sleeping lapdog very similar to the one in the *Venus of Urbino*, there is a clock topped with a statuette, probably a *memento mori* or display of the kind of sophisticated artistic and technological objects that the dukes could procure and also intrigued Titian.

The portrait of Guidobaldo della Rovere (1514–1574), the couple's son and hence Vittoria's great-grandfather, often styled as Guidobaldo II to distinguish him from his Montefeltro great-uncle (portrayed by Raphael in a fine bust-length portrait also at the Uffizi) was the prestigious commission that gave Bronzino the opportunity to demonstrate his talent for official portraiture. We learn from Vasari that Bronzino had to wait in Pesaro, while Duke Francesco Maria was away for an extended period, for the arrival of the armour from Lombardy in order to paint the eighteen-year-old Guidobaldo, who wanted to be portrayed with armour in the

Milanese style, his large imposing dog and his hand resting on his helmet to symbolise his military responsibility. There is a cartouche on the helmet with a Greek inscription that roughly translates as 'It will certainly be as I have decided'. This motto, reinforced by its position near the fashionably padded codpiece, is linked to a clash with his father, who wanted to force Guidobaldo into an advantageous marriage to the heir of the duchy of Camerino, Giulia da Varano, while the young man had his heart set on Clarice, daughter of the condottiere Gian Giordano Orsini. However, faced with the risk of seeing his rights transferred to his younger brother, who had been born in the meantime, Guidobaldo yielded to his father's will.

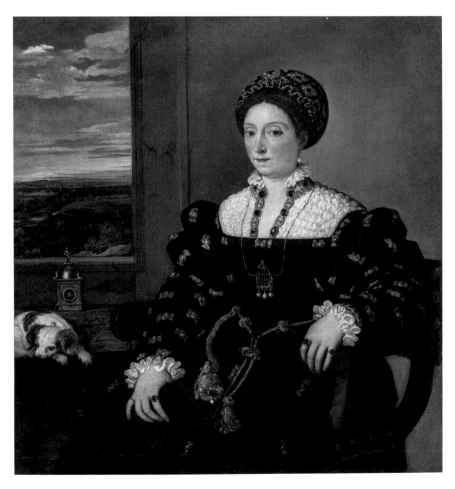

Tiziano Vecellio, *Eleonora Gonzaga*, c. 1536-1538, oil on canvas. Gallerie degli Uffizi.

Bronzino, *Guidobaldo della Rovere*, 1532, oil on panel. Galleria Palatina. ▶

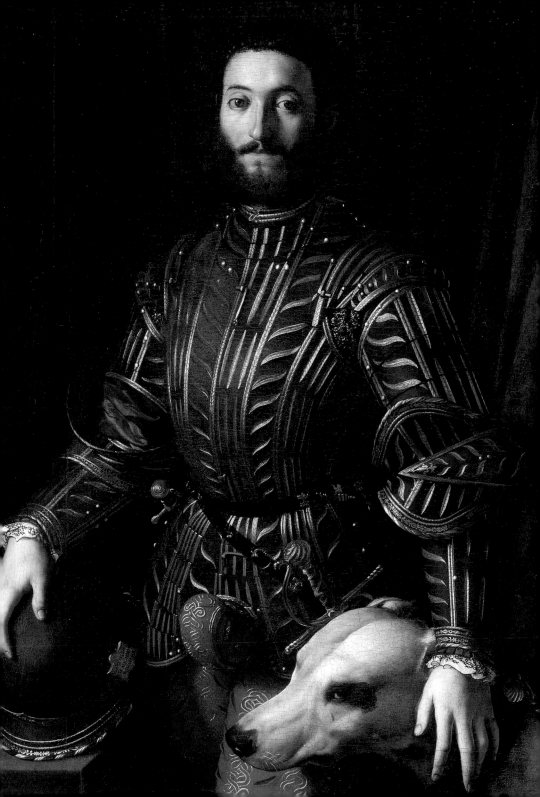

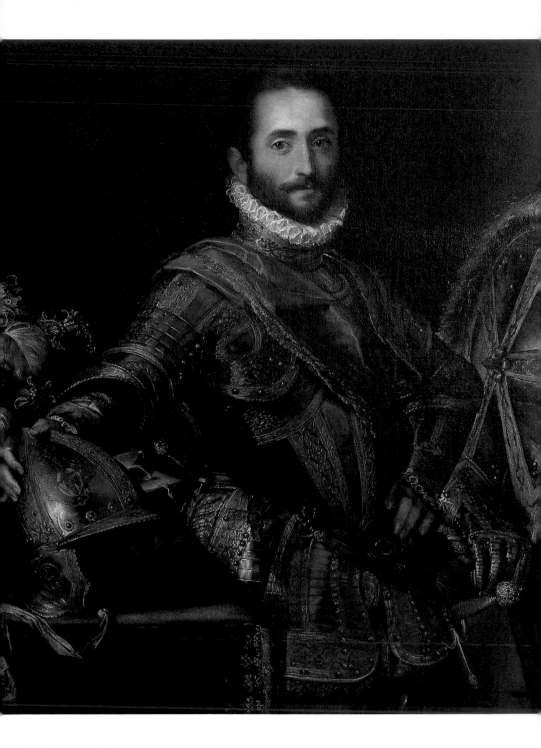

When Giulia died, Guidobaldo married Vittoria, the daughter of Pier Luigi Farnese, illegitimate son of Paul III. The couple's son Francesco Maria II (1549–1631), sent at a very young age to the court of Philip II of Spain, was forced to return to his father's home when he expressed his intention to marry a Spanish girl instead of the bride Guidobaldo had chosen, Lucrezia d'Este, who was fifteen years his senior.

Francesco Maria's portrait was commissioned by his father from the Urbino-born painter Federico Barocci to celebrate the military prowess of his son who, despite his young age, had distinguished himself in the Battle of Lepanto (7 October 1571), a naval engagement in which the Holy League defeated the fleet of the Ottoman Empire. The model for the composition was the young man's namesake grandfather, but Barocci had the prince pose at length, mastering his physiognomic and psychological particularities and enlivening his gaze with three white dots in his pupils. The richness of the fully decorated armour is unusual, completed by a shield embellished with feathers and the sallet upon which the sitter rests his hand, which is depicted with virtuosic foreshortening, a pictorial device that might have derived from Titian's portrait of Philip II, now lost, but that Francesco Maria could have seen in Madrid. Amidst the overabundance of objects, including the cold steel hanging from the prince's belt, the sash worn diagonally across his chest stands out, one of the brightest points of the palette of vivid hues that make Federico Barocci's paintings so immediately recognisable. The duchy of Urbino flourished under Francesco Maria II: the Most Serene, a title he received from the pope in 1582, ruled with the approval of the populace and lived immersed in reading – there are already a few books in the youthful portrait by Barocci – but his marriage to Lucrezia d'Este, which he bore with a heavy heart, was childless and in the end the duchess, who had already returned to live at the lively Ferrara court, accepted the conditions of a de facto separation. In 1599, by this point fifty years old and finally a widow, Francesco Maria married his cousin Livia della Rovere, who was just fourteen and chosen by Vittoria Farnese as the perfect candidate for giving birth to the long-awaited heir. On 16 May 1605, the feast of St Ubaldo, patron saint of Gubbio, the city of the Della Rovere duchy, Federico Ubaldo della Rovere was born, portrayed in a portrait by Alessandro Vitali with the inscription federigo principe di urbino quando nacque 1605 (Federigo prince of Urbino born 1605). It is a rare subject, modelled on depictions of the Christ Child, and shows the contemporary custom of swaddling newborns so that they could not move. The Galleria Palatina also preserves another painting of a newborn, *Leopoldo de' Medici in Swaddling* (1618), now attributed to Jacopo Ligozzi. The heraldic symbol of acorns amidst oak leaves is embroidered in gold on all the fabrics, from the white pillowcase to the swaddling and the cover lined in red satin, expressing the dynastic importance of the baby. In the archive of the duchy of Urbino, which also came

◄ Federico Barocci, *Francesco Maria II della Rovere*, 1572, oil on canvas. Gallerie degli Uffizi.

with Vittoria to the banks of the Arno and is now part of the Archivio di Stato, Florence, there is mention of a payment made to Vitali for this painting on 8 June 1605. As mentioned above, Federico Ubaldo married Claudia de' Medici in 1621. On 3 November of that same year, his father handed over the reins of government, withdrawing into private life, but the premature death of Federico Ubaldo, known for his debauched lifestyle, forced Francesco Maria to take them up again until 1625, when he gave in to pressure from the pope, accepting an ecclesiastic governor and marking the end of the duchy of Urbino, permanently annexed to the Church State when the duke died in 1631.

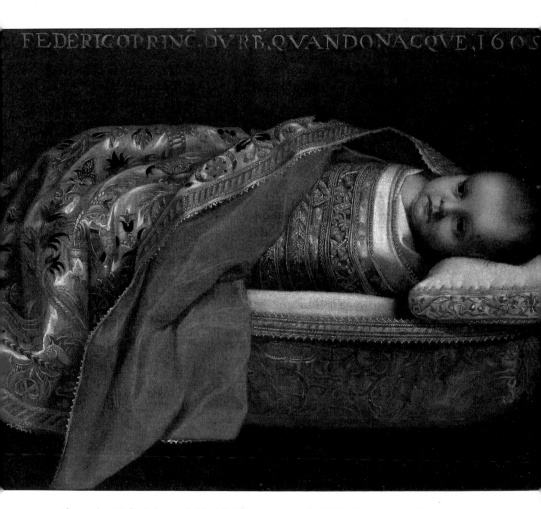

Alessandro Vitali, *Federico Ubaldo della Rovere in the cradle*, 1605, oil on canvas. Gallerie degli Uffizi.

AN INFERNAL MARRIAGE
COSIMO III (1642–1723) AND MARGUERITE LOUISE D'ORLÉANS (1645–1721)

The portraits of Cosimo III and his wife Marguerite Louise d'Orléans, attributed to Giovanni Gaetano Gabbiani, are probably more in harmony than the couple itself ever was. Of the same dimensions and composition, the paintings show the sovereigns in a colonnaded space that, pushing aside the heavy drapes, leads outdoors. Both wrapped in ermine, the grand dukes each stand next to a table covered in red velvet and resting upon which are their crowns, with curved points supporting the globe, a symbol of the 'royal treatment' granted by the emperor in 1691 and later by the pope. A recognition deeply coveted by Cosimo – by this point 'Most Serene Highness' – since it had already been obtained by his old rival Victor Amadeus II of Savoy.

Cosimo is presented in the armour of a military leader: beneath his mantle we can glimpse the red insignia of the chivalric Order of St Stephen and his right hand grips the high commander's staff, although his military strategy for the most part comprised economic support for the battles of others, when forced by relations of vassalage and political advantage. Despite his mystical inclinations and shy nature, Cosimo had to marry. His parents arranged a marriage to Marguerite Louise d'Orléans, who was the granddaughter of Marie de Médicis and therefore the cousin of Louis XIV, king of France. The wedding was held in 1661, but the young bride mourned for the glittering court at Versailles even before she set foot in the one at Florence, which, the splendours of the past long left behind and made grey by the religious passion of Cosimo and his mother, could hardly be described as lively. Marguerite Louise was eaten away by her yearning to return to Paris. After fourteen years of infernal cohabitation, she feigned an illness that she claimed could only be cured in France and, with three small children, obtained permission in 1675 to withdraw to a convent in Montmartre, where her behaviour was at times untoward, irritating even her cousin the Sun King. From the papers of Florentine diplomats and the correspondence, it would seem that back in France Marguerite Louise tormented everyone who had anything to do with her, while Cosimo in Florence received requests for money and fiery complaints about his call for more modest conduct: 'You are driving me into such a state of despair that no hour of the day passes when I do not desire your death and wish that you were hanged. ... If however you do not change your treatment of me, and I swear by what I loathe above all else—that is yourself—that I shall make a pact with the devil to enrage you and to escape your madness. Enough is enough. I shall engage in any extravagance I so wish in order to bring you unhappiness, and you cannot stop me. Your devotion is in vain and you can do as you wish, since you are like rue, God doesn't want you and the Devil rejects you,' Marguerite Louise wrote to her husband from the convent at Montmartre on 8 January 1680.

No Medici ruled as long as Cosimo III (fifty-three years of unremarkable government, unaided by the economic situation), but nor did any of them travel as much as he, a grand prince, winning admiration at courts and universities across Europe. His passion for geography is documented in his uncommon collection of valuable eighteenth-century maps, including the oldest-known representation of New York.

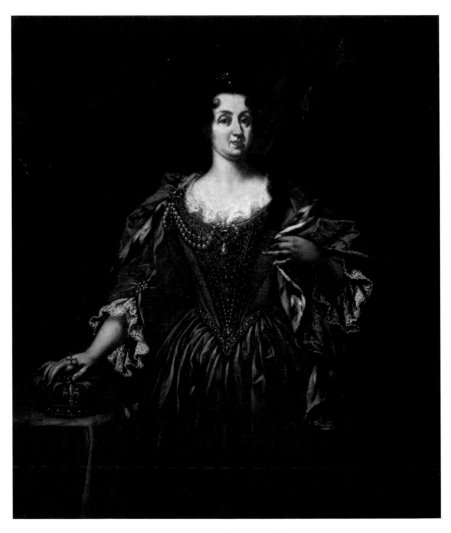

Giovanni Gaetano Gabbiani, *Marguerite Louise d'Orléans*, 1723, oil on canvas. Gallerie degli Uffizi.

D espite their marital conflict, Cosimo III and Marguerite Louise managed to ensure the continuity of the dynasty. When the grand duchess returned to Paris, she left her children behind in Florence: Ferdinand (thirteen years old), Anna Maria Luisa (eight) and Gian Gastone (four). After lengthy negotiations to unite their elder son and Infanta Isabel Luísa, heir to the Portuguese throne, ended in failure, the grand duke chose Violante Beatrice (1673–1731), daughter of

Giovanni Gaetano Gabbiani, *Cosimo III de' Medici*, 1722, oil on canvas. Gallerie degli Uffizi.

Duke Ferdinand Maria of Wittelsbach, elector of Bavaria. Cosimo, however, had to reckon with Ferdinand's reluctance to marry. A brilliant patron of the arts, passionate about music and theatre, and constantly surrounded by favourites, the great prince agreed to the match on condition that his father permit him a pleasure trip to Venice. On 9 January 1689, Violante was finally received in Florence with all the pomp typical of the Medici for such occasions. Culturally similar to Ferdinand, and especially passionate about poetry, Violante was more tied to her husband by intellectual interests than true married life: in 1713, Ferdinand died childless, having wasted away from the syphilis that he had in all probability contracted during another stay in Venice. Violante remained in Tuscany, dividing her time between the Florentine court and Siena, where she was governor. It was indeed her edict that put an end to the territorial disputes between the Sienese contradas, defining the boundaries between them once and for all in 1730.

In 1690, Anna Maria Luisa de' Medici had married Johann Wilhelm II von Wittelsbach, Elector Palatine (1658–1716) and then pushed for her brother Gian Gastone's marriage to the bitter Anna Maria Franziska of Saxe-Lauenburg (1672–1741), widow of Johann Wilhelm's brother. These marriages were also childless. Unlike what had been the case in previous generations, Cosimo III could count on just one brother, Cardinal Francesco Maria (1660–1711), who had been born eighteen years after him during a brief reconciliation between their parents. For age and affinity, therefore, the prelate had been the companion of his nephew Ferdinand, who happily went to stay with him at his cheerful residence at Lappeggi, a villa that he had had remodelled according to the lavish plan of the architect Antonio Maria Ferri, but for half the quoted amount (the architect had made an estimate, the cardinal found it too high, but, not wanting to give up the plan, asked him to halve the price, skimping on materials, since he was only interested in enjoying it, not leaving it to posterity, and so all he cared about was a guarantee that it would hold up until he died). When this brother was forty-eight, surrounded by comfort, decorated with the honorific title of cardinal protector of the French and Habsburg crowns, but in bad shape physically for his excesses, Cosimo asked him, in 1709, to set aside the cardinal's cap and marry the twenty-three-year-old Eleonora Gonzaga di Guastalla to give Tuscany the coveted heir. Arriving in Florence and seeing the groom, the young woman refused to come near him: a reluctance overcome after much prayer, but in vain, because after just two years Francesco Maria died childless and by that point having lost all his previous prestige. Cosimo III, advanced in years, knew that without male heirs numerous European houses would claim the grand duchy, since it was an imperially granted title. After much heated debate and without paying much heed to Cosimo's protests that the Medici should be the ones to choose their own successors, Great Britain, France, the Netherlands, and then also Austria, decided on Charles of Bourbon, infante of Spain, son of Elisabetta Farnese, the last of her line, duchess of Parma and Piacenza and great-granddaughter of Margherita di Cosimo II de' Medici.

THE LAST MEDICI GRAND DUKE
GIAN GASTONE (1671–1737)

In 1737, Gian Gastone de' Medici had his portrait painted by Franz Ferdinand Richter, an artist originally from Silesia, but who had spent most of his career in Italy. It is a monumental painting in the Rococo style, where everything is decorative: the sumptuous clothing, lavish furnishings covered with richly embroidered damasks and glossy velvets and even the cityscape beneath a threatening sky. Besides the ermine mantle, a symbol of his rank along with the sceptre and crown, the last grand duke of the Medici family is wearing a powdered wig, fashionable at the time, and a priceless garnet- and diamond-encrusted cross of the Order of St Stephen that emerges from beneath his lace collar. Pulling back his heavy robes, Gian Gastone reveals the helm of a sword that is described in the Medici inventories as counting an astonishing 337 diamonds. The window opens onto a view of Florence with Brunelleschi's dome and Giotto's bell tower. Between the city and the grand duke is the statue of the *Marzocco*, protector of Florence, but here the lily on the lion's shield has been replaced with the Medici crest. The painting was made in the last year of the grand duke's life and possibly completed after his death, which might explain the darkened sky.

Gian Gastone's personality was not strong enough to counter his father's dismissive attitude and the vicissitudes of life. He had been married against his will to the dour Anna Maria Franziska, daughter of the last duke of Saxe-Lauenburg, who never wanted to set foot on Tuscan soil, not even after her husband's coronation, preferring to take care of her horses in Bohemia while her husband plunged into melancholy, gambling debt and alcoholism. Once he literally escaped married life and returned to Palazzo Pitti, he surrounded himself with a group of salaried men and women, which came to number more than 350 individuals, recruited by his powerful favourite Giuliano Dami. These indecorous, social climbing profiteers, ready to satisfy Gian Gastone's every request or fantasy, were called 'Ruspanti' after the name of the coin they were paid with two times a week, the ruspo. Gian Gastone spent most of his life in bed, prey to ill health and depression that did not, however, stop him from sometimes being a good ruler: he suspended the application of the death penalty, provided tax relief for the poorest citizens and clearly separated state prerogatives from ecclesiastic ones, even in disagreement with the deeply religious Cosimo III, who considered one of his most important titles to be that of Lateran canon, received from the pope during the 1700 Jubilee, on the strength of which he had been able to show the Roman public some highly venerated relics and even give his blessing to bystanders. Gian Gastone does not seem to have been upset by the arrival in Florence of Charles of Bourbon, the young and energetic son of Elisabetta Farnese ready to succeed him on the throne, but the cards of history were destined to be reshuffled. In February 1733, the elected king of Poland Augustus II died. Stanisław Leszczyński, father-in-law of Louis XV of France, claimed the throne, triggering a war that lasted two years. The international balance was restored with difficulty: the eldest son of Augustus II became

king of Poland, the Savoy obtained Milan, Austria won recognition of the Pragmatic Sanction – thanks to which Maria Theresa of Austria ascended the throne and became one of the most important political figures of the eighteenth century – and the Farnese territories, and Charles gained Naples and Sicily. France, through Leszczyński, annexed Lorraine and, in compensation, Francis Stephen of Lorraine, who would soon after marry Maria Theresa of Austria, became the successor of the Medici in Tuscany.

Franz Ferdinand Richter, *Gian Gastone de' Medici*, 1737, oil on canvas. Galleria Palatina.

THE MEDICI'S GIFT TO YOU

Anna Maria Luisa (1667–1743)

By this point a widow, Electress Palatine Anna Maria Luisa de' Medici left the lively court at Düsseldorf in 1717 to return to Florence where she was joyfully welcomed by Cosimo III who, after the death of Grand Prince Ferdinand in 1713 without an heir, had altered the laws of succession to lay claim to the grand duchy, in hopes that the other European states would give their assent. International approval was not forthcoming, contrary to what had happened with the contemporary Pragmatic Sanction. When Gian Gastone died, Anna Maria Luisa,

Antonio Franchi, *Anna Maria Luisa de' Medici*, 1689-1691, oil on canvas. Galleria Palatina.

the last, extremely wealthy descendant of the Medici, had no other choice but to recognise Lorraine as her heir. However, the wisdom of this woman, worthy of her extraordinary forebears, led her to carry out a revolutionary act of inestimable tangible and moral value. On 31 October 1737, a legal document known as 'Family Pact' was ratified, according to which: 'The Most Serene Electress cedes, gives, and transfers to His Royal Highness at the present moment, for him and for successive Grand Dukes, all the furniture, effects, and rarities from the succession of her brother, the Most Serene Grand Duke, such as Galleries, Paintings, Statues, Libraries, Jewels and other precious things such as Holy Relics and Reliquaries and the Ornaments of the Chapel of the Royal Palace, so that His Royal Highness commits himself to preserve them with the express condition that nothing which is for the ornament of the State, for the use of the public, and to attract the curiosity of foreigners will be transported or taken away from the Capital and State of the Grand Duchy.' Securing a ban on transferring the peerless collections accumulated by the Medici over the centuries, Anna Maria Luisa elevated Florence to the status of a world capital of culture and its residents, by birth or by choice, to that of a privileged population immersed in beauty, in the company of scholars and visitors from all over the world, united by a thirst for knowledge. With the unification of Italy, the honour and duty to preserve and valorise the gift from the last descendant of the Medici house passed to the Savoy and then the Italian Republic.

Anna Maria Luisa was portrayed in numerous portraits reflective of the taste of her age, whether in the guise of Flora or Minerva, in fancy dress, in the midst of dancing or the hunt. One portrait in particular stands out for its intensity, painted by Antonio Franchi in all likelihood for the gallery of the 'Oval Beauties' created by Violante of Bavaria, in which the princess wears her hair in the style fashionable at the time, with two long curls draped over her shoulders. To someone looking at this painting today, it might look like an old photograph, due to its large oval shape, close-up view that leaves out the hands and a kind of selective blurring created by different ways of handling the paint: sharp and smooth for the complexion and features, loose and textured for the metallic fabrics and shiny jewels.

As with old photographic portraits, the relatively small size of this painting allows only one viewer at a time to look into Anna Maria Luisa's eyes, each of us prompted to ask ourselves how best to use her gift, which has made Florence a place to encounter the height of the capabilities of human brilliance.